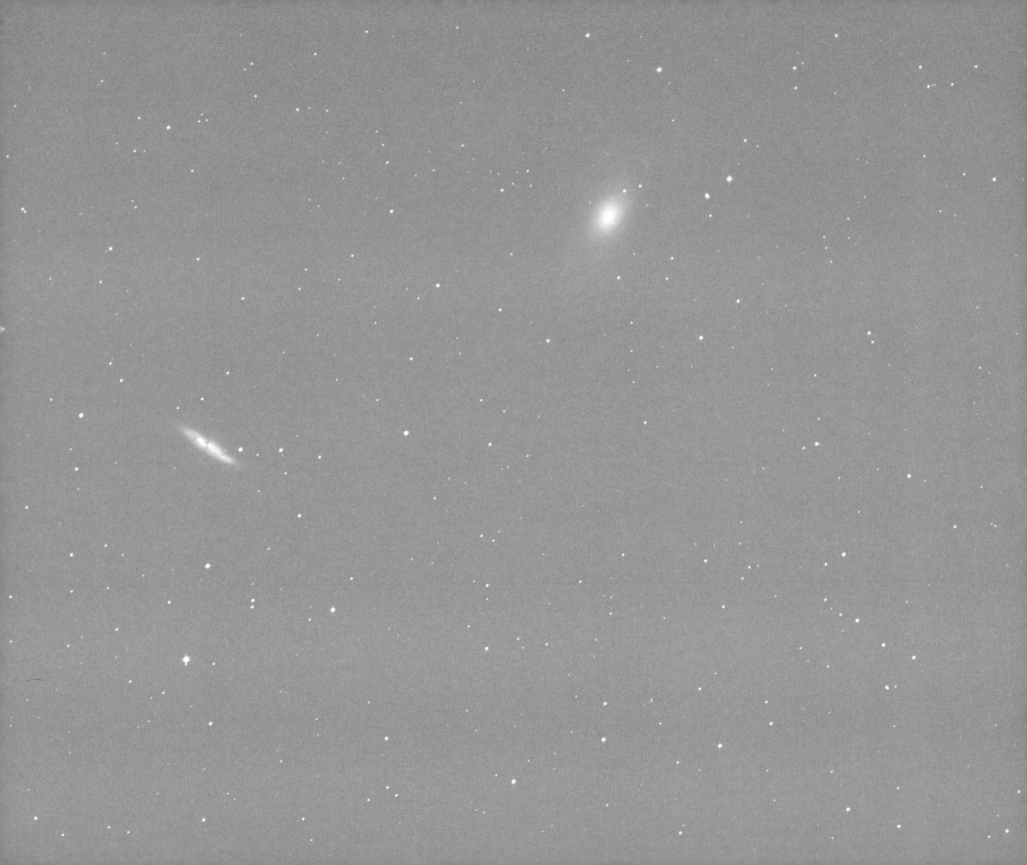

# STARGAZING

# STARGAZING

PHOTOGRAPHS OF THE NIGHT SKY FROM
THE ARCHIVES OF NASA

PREFACE *by* BILL NYE

TEXT *by* NIRMALA NATARAJ

CHRONICLE BOOKS

SAN FRANCISCO

Library of Congress Cataloging-in-Publication Data
Names: United States. National Aeronautics and Space Administration, author.
 | Nye, Bill, writer of preface. | Nataraj, Nirmala, writer of added text.
Title: Stargazing : photographs of the night sky from the archives of NASA /
 preface by Bill Nye ; text by Nirmala Nataraj.
Description: San Francisco : Chronicle Books, [2019] | Includes
 bibliographical references.
Identifiers: LCCN 2018045946 | ISBN 9781452174891 (hardcover)
Subjects: LCSH: Astronomical photography. | Sky–Pictorial works. | Night
 photography. | United States. National Aeronautics and Space
 Administration–Photograph collections. | Outer space–Pictorial works.
Classification: LCC QB121 .U56 2019 | DDC 520.22/2–dc23 LC record available at https://lccn.loc.gov/2018045946

Manufactured in China.

Design by Kristen Hewitt.

10 9 8 7 6 5 4 3 2 1

Chronicle books and gifts are available at special quantity discounts to corporations, professional associations, literacy programs, and other organizations. For details and discount information, please contact our premiums department at corporatesales@chroniclebooks.com or at 1-800-759-0190.

Chronicle Books LLC
680 Second Street
San Francisco, California 94107
www.chroniclebooks.com

# CONTENTS

# PREFACE

*by* BILL NYE

Tonight, look—just look up and out at the night sky. The scale of the cosmos is more than anyone can grasp. But with this book, you can give it a try. Reach out, and hold a finger at arm's length. Now swing your arm skyward, and gaze up. You're occluding more stars from your view than you could count in a lifetime. Hence the expression "billions and billions." As you look at the stunning pictures in this volume, I hope you get a wonderful sense of just how much there is to see out there. Most of us are city dwellers; we can see only a tiny fraction of what's up at night. Even on a moonless night, our cities produce so much light that we only perceive a few bright points: Jupiter, Saturn, or Mars, the "red planet," which glows just a little bit orange, by the way. But if you can take the time to get out and away from city lights, you'll get a glimpse of our beginnings. You'll look in on where we all came from.

Through millennia of diligent observations, stargazer scientists have discovered that all the chemical elements—all the water, all the air, indeed all of whatever molecules make up you and me—are made of the atomic material of ancient stars. It all gets driven into the blackness of space by explosions, brought on when the extraordinary process of stellar fusion overwhelms the crush of gravity in a star. Along with the glowing stars in the night sky, then, is the dust of other stars, and it's the dust that comprises everything you know and love. To get a few good looks at all those stars and all that dust up close, turn these pages.

Because of a drive deep within us to know the cosmos and our place within it, and a drive to keep ahead of others of our kind (who might be members of other tribes, other lands, and other countries), we've designed and built extraordinary means to capture images of the night sky. Earth's citizens invest billions of dollars, euros, rupees, yuan, and yen in the means to study the heavens. Taxpayers around the world have funded and built optical telescopes, radio dishes, and amazing spacecraft, as well as whole cities to support them. Here in the United States, the organization doing this work is the renowned National Aeronautics and Space Administration. It's so famous that its acronym is enough: NASA evokes respect for technical achievement, remarkable accomplishment, and wonderment for our Earth's place in outer space. So, this book is a compilation of some of the remarkable and frankly astonishing images that NASA has captured through its nightly work over the last six decades. It shows again that space exploration brings out the best in us. These NASA photographs of stars, taken from the ground and from the spacecraft built to study them, fill me with admiration and awe. Even photographs of our spacecraft and the rockets to launch them are amazing. In a glance, you get a sense of the remarkable power and thrust required to send our instruments and astronauts into the darkness.

Like a great many high-quality books, this one is printed on smooth white paper, and the words are produced with jet-black ink. But unlike almost every book you'll ever hold in your lap and admire, this one has large sharp rectangles of black carrying the awesome colorful details of our Earth's sky at night. Here's hoping this book inspires you to admire every page and to go out and see it all for yourself.

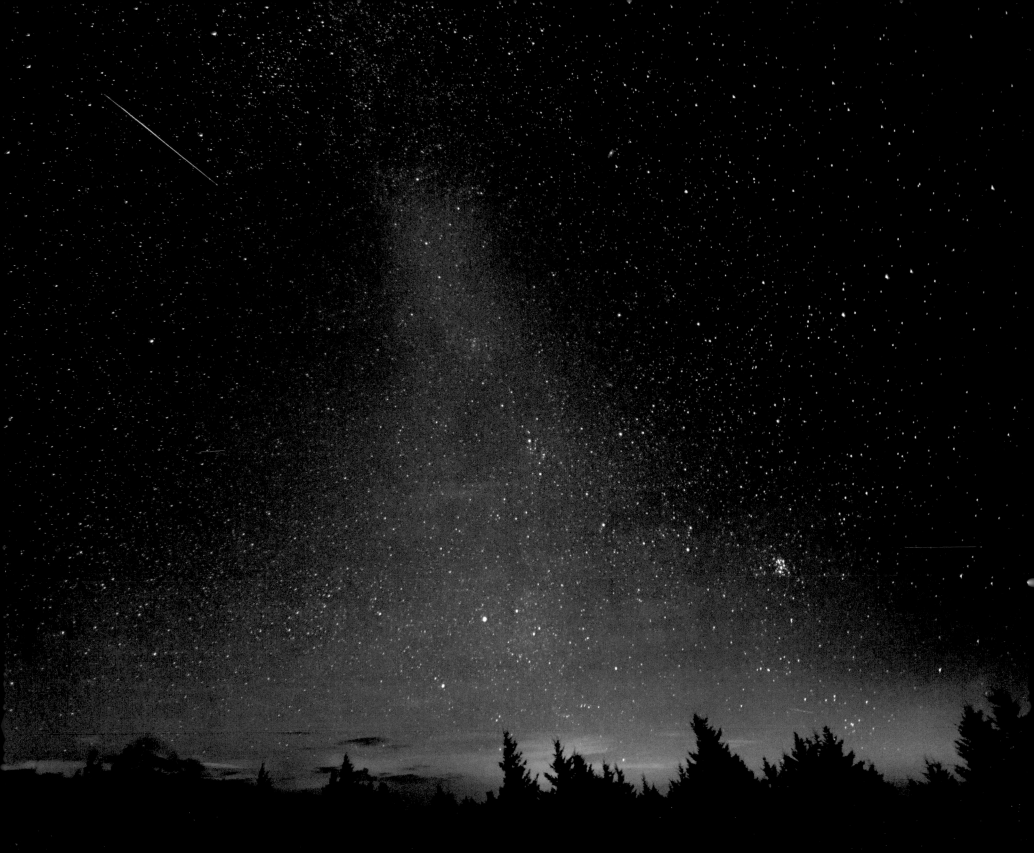

# INTRODUCTION

Is there anything to rival the beauty of a clear night sky? The mathematician Ptolemy poetically described the archetypal awestruck gaze that humans cast up into the firmament: "I know that I am mortal by nature, and ephemeral; but when I trace at my pleasure the windings to and fro of the heavenly bodies I no longer touch the Earth with my feet: I stand in the presence of Zeus himself and take my fill of ambrosia."

Whether we gaze up and out into the cosmos to better understand our place within it, to chart a course through unknown waters, to determine our proximity and relationship to other celestial bodies, or simply to drink in the beauty and mystery of the fathomless reaches of space, the night sky is a destination of timeless wonder.

Today, we use binoculars, telescopes, ground and space observatories, or simple apps on our smartphones to determine the placement of stars and galaxies (or even a satellite whizzing just outside Earth's atmosphere). But stargazing was something that any amateur sky watcher could do without obstruction for most of human history. Many ancient civilizations used the stars for accurate navigation, and still others used them as markers for myths and illustrations of cultural values writ large in the skies. And the star maps that early scientists created, even in ancient times, would come to inform the modern eye.

To our knowledge, the first comprehensive star atlas was created in 650 CE in Western China, in a small town along the Silk Road. It appears to have been carefully inscribed on a piece of paper, and was found in a temple back in 1907, when a Taoist monk accidentally crashed into a wall and stumbled upon an ancient archive of documents and sculptures.

The first telescopes emerged in the seventeenth century. They evolved from earlier models, used by the likes of Galileo and Isaac Newton, to a 150-foot-long (46-meter-long) device designed by Johannes Hevelius (touted as the founder of lunar topography). In 1609, Galileo was the first person to record the night sky with the use of a telescope. His first significant discovery was that certain "stars" in the sky were actually moons that orbited Jupiter.

Unfortunately, the quality of glass in those early telescopes provided feeble magnifying power. Scientists wouldn't be able to corroborate their theories about the stars until stronger telescopes were developed—which would only come about in the 1770s, when the musician William Herschel turned his attention to designing telescopes. Through trial and error, as well as a meticulous study of the skies above Bath, England, he came upon something major: Uranus wasn't a star, but a planet.

---

< **PERSEID SHOWER 2016**

This 30-second exposure captures a meteor streaking across the sky in Spruce Knob, West Virginia. Upon entering the atmosphere, a meteor compresses the air in front of it, which can heat the meteor up to 3,000 degrees Fahrenheit (1,650 degrees Celsius). Most meteors are vaporized, generating the shooting stars we see in the skies. The annual Perseid shower is most visible right before dawn, when the area of Earth closest to the Sun during Earth's orbit picks up even more meteoric debris. The best way to observe the Perseid shower is to allow your eyes to adjust to the dark for roughly 45 minutes, and then simply lie on the ground and look up.

From that point on, our understanding of the cosmos transformed. Uranus was the first planet to be "discovered" since antiquity. After being promoted to court astronomer by King George III, Herschel continued to fine-tune his telescopes and delve into the mysteries of the universe. He boasted, "I have looked farther into space than ever a human being did before me. I have observed stars of which the light, it can be proved, must take two million years to reach the Earth."

The study of the night sky also underwent a renaissance in the late nineteenth century with the advent of astrophotography. The naked eye and the telescope were no longer the sole tools of ardent sky watchers. Now, photographing astronomical phenomena became a serious discipline—especially after the innovations of dry plate photography, which helped scientists and photographers learn more about deep space. Photos of nebulae, star clusters, and galaxies began to emerge after 1871. Longer exposure times also helped us capture glimpses of dimmer, more distant stars and cosmic phenomena.

In 1923, astronomer Edwin Hubble used astrophotography to locate the Andromeda Galaxy and determine Earth's distance from a number of Cepheid variable stars, which are extremely luminous stars that pulsate at predictable intervals. Without photographing and recording the positions and brightness of the Cepheid variables over time, Hubble would not have been able to measure their distance—which then led him to the discovery that Andromeda was actually its own galaxy, existing outside the Milky Way. This discovery revolutionized our understanding of space; Hubble proved that the clouds of light sometimes visible in the night sky were galaxies that existed well beyond the Milky Way and theorized that there were countless galaxies in the cosmos. Hubble's astrophotography remarkably expanded our measurements of the universe.

Today, with space-based telescopes like the Hubble, as well as ground observatories, scientists are compiling data beyond the scope of what most scientists of the past could have imagined. However, many astronomers still continue to create star maps and locate distant bodies in our night sky—if only to condense the sheer scale of the universe into something that is closer to home.

Because the motion of the Earth and the passing of the seasons always change our relative view of the sky, you don't have to be an atlas maker or scientist to appreciate everything from constellations to meteor showers. At an early age, many of us learn simple methods for identifying constellations like the Big Dipper (Ursa Major). Just locate the bright North Star, which is about a third of the way up from the horizon to the top of the sky. If you trace a line from the North Star down, you'll find the two stars at the end of the Big Dipper's handle. The North Star is also the brightest star in the Little Dipper, toward the end of its handle. Orion's Belt is another easy-to-spot constellation containing three bright stars. If you look to the lower right of the belt, you'll see a vertical row of faint, fuzzy stars that make up Orion's Sword. The middle "star" is actually the Orion Nebula, one of the brightest cosmic gas and dust clouds in the night sky.

Of course, the rules change when you're in the Southern Hemisphere! While the North Star is high in the sky in the Northern Hemisphere, it sits on the horizon close to the equator and disappears altogether when you travel below the equatorial belt. Because the Southern Hemisphere is less impacted by light pollution than the Northern Hemisphere, it offers a number of celestial spectacles that are invisible to many of us in the north; this includes nearby stars, dwarf galaxies, and magnificent star clusters. Additionally, common constellations in the north, such as the Big Dipper, Cassiopeia, and Cepheus, appear to be "upside down" south of the equator.

## OTHER THINGS YOU MIGHT FIND IN THE NIGHT SKY

The photographs of the night sky that you will find in this book include images of lunar and solar eclipses, noctilucent (night-shining) clouds, lightning, and the vibrant auroras at the magnetic poles of Earth. These images were captured from Earth and from the deck of the International Space Station (ISS), an artificial satellite in low orbit around Earth. In addition, you'll discover images of deep space taken from both ground

## BRIGHT ANDROMEDA

This radiant image shows Messier 31, also known as the Andromeda Galaxy. The 10-minute exposure was taken at the New Mexico Skies observatory. Andromeda can be observed on dark nights, during which it appears six times wider than the full Moon through binoculars; with the naked eye, its visible portion appears as a cloudy disk roughly the same size as the Moon. If the vast spiral arms of the galaxy were visible, it would take up roughly 20 degrees of night sky, or the equivalent of 40 full Moons. The galaxy is massive, holding around 1 trillion stars, compared to between 100 and 400 billion in the Milky Way. However, the Milky Way is considerably heavier than Andromeda. We think that's because the former harbors more dark matter and energy.

and space observatories, showing phenomena that are nearly impossible to see without a telescope. One exception, of course, is the Andromeda Galaxy, which is the most distant body in space that we can observe with the naked eye, at 2.537 million light-years away.

You'll find several images of meteor showers—such as the Leonids (connected to Comet Tempel-Tuttle) or the Perseids (connected to Comet Swift-Tuttle). A meteor shower occurs when Earth passes through the orbit of a comet that has left behind some debris in its wake. While the meteor showers can sometimes be obscured by light pollution or the brightness of a full moon, they can provide hours of rapt sky-watching. Comets, too, are rare sights that are often visible without telescopes. The only comet that comes back toward Earth frequently enough for many of us to witness it at least once during our lifetimes is Halley's Comet. It visited our cosmic neighborhood most recently in 1986 and returns every 76 years.

Then, of course, there are the familiar planets that are visible in the night sky most of the year: Mercury, Venus (the third-brightest object in the sky, after the Sun and Moon), Mars, Jupiter, and Saturn. If you've ever wondered what ultimately distinguishes a star from a planet, it really all comes down to light. Stars emit light generated by internal nuclear fusion, while planets only reflect a portion of sunlight. We know that a body in the sky is a planet because its position shifts gradually against the background stars, and its brightness varies depending on its distance from Earth. Stars, in contrast to planets, also appear to twinkle due to turbulence in Earth's atmosphere, while the much-closer and comparatively larger planets emit a steadier light. If you can identify two planets in the sky and connect them with an invisible line, you've found a part of the ecliptic plane, which is the trajectory the Sun follows through its rising and setting. In fact, if you simply follow this path through the sky, you're likely to identify even more planets.

This book also contains images of supernovae. A supernova is the largest cosmic explosion known to us. A star can become a Type 1 supernova (when it accumulates matter from a nearby star, triggering a massive nuclear reaction) or a Type 2 supernova (when the star's reserves of nuclear fuel diminish and it collapses under its own gravity). Although we don't have an accurate estimate of how frequently supernova explosions happen, scientists surmise that they occur somewhere between once every 20 years and once every 200 years. Because of obstructing clouds of gas and dust in space, many supernovae aren't visible to us. The last supernova on record that was so bright it could be seen during the daytime was in 1572. And even further back, in 1006, we have the brightest recorded stellar moment in history: a supernova that surpassed the brightness of Venus by 16 times and was recorded by people in China, Japan, Iraq, Egypt, and Eastern Europe.

Then, of course, there is the familiar sight of the Milky Way, which looms high in the sky during the summer and low in the winter in the Northern Hemisphere. In the Southern Hemisphere, it's possible to see the Milky Way high overhead during the winter, in even greater detail. The best season for catching a glimpse of the Milky Way anywhere in the world is mid-March through mid-October, a period of time during which the Sun does not obscure the bright galactic center (the core around which the galaxy revolves) as prominently. In the Northern Hemisphere, the galactic center can be seen in the southern part of the sky; and in the Southern Hemisphere, you'll spot it in the northern part. For the most part, the Milky Way resembles a cloudy band that streaks across the sky. In the area where it appears thickest are thousands upon thousands of stars, many light-years away. Many astronomers and astrophotographers suggest viewing the Milky Way in a dark area where there are no streetlights for about 20 miles; around 11 p.m. on a summer night in the Northern Hemisphere is an ideal time for observation.

While distant swaths of the universe are visible to us, we can also identify phenomena much closer to home. Sometimes during the day or night you can spot the ISS. It orbits at between 205 and 270 miles (330 and 435 kilometers) above the surface of the planet, moving at about 17,500 miles (28,000 kilometers) per hour. NASA even has a website that tracks the ISS and lets you know when the next sighting in your particular region will be. Sometimes, the ISS is the third-brightest object in the night sky, depending on its position—for example, whether it's close to the horizon or farther off.

Astronomers often suggest learning to identify planets and constellations with the naked eye, and getting a sense of how their positions change over time throughout the year. The ability to navigate the sky this way makes using a telescope easier. Astronomers also suggest observing the sky on cold, clear winter nights; humidity is more present in the summer and can create hazy views. It's best to stargaze during a crescent or gibbous moon phase, or a dark moon. The light of the full moon can be stunning, but it also blots out the remainder of the night sky. But if you want to observe the Moon itself, through a telescope or binoculars, it's best to do so during the waxing or waning phases, when the Moon's shadows provide greater detail and texture.

Although your specific location, the weather conditions, and the level of light pollution will determine your view of the night sky more so than your tools will, telescopes and binoculars will enable you to identify cosmic phenomena such as star clusters or the rings of Saturn. More than 9,000 stars are visible, but only about 2,000 of them are visible to the naked eye without using a telescope or binoculars. A small number of these stars are similar in luminosity and size to our Sun, which is a middle-aged yellow dwarf star. The remainder are much larger, and often thousands of times brighter. There are approximately 400 stars that tend to be visible in urban areas. Among the 50 brightest stars in the sky, Alpha Centauri (which is 4.367 light-years from Earth) is the dimmest—and it is 1.5 times brighter than our Sun! Some stargazers have reported seeing particularly bright stars in the daytime sky, but this is unusual, unless a solar eclipse enables such observation.

## THE FUTURE OF NIGHT SKY-WATCHING

As stunning and awe-inspiring as the night sky is, light pollution has cast its sickly glow over many of us in the modern world. In fact, 80 percent of North Americans and 60 percent of Europeans—the populations most impacted—are unable to clearly see the Milky Way due to light pollution. Human-made alterations of light levels during the night don't merely cause problems for sky watchers; they also impact the nighttime navigation of birds and disrupt the mating and birthing patterns of various animals. Because light pollution can spread hundreds of miles from its source, it has also crept into dark sky parks and preserves, areas that restrict light pollution in order to promote astronomical observation. The areas with the least amount of light pollution, according to what people have reported being able to observe, are Chad, the Central African Republic, and Madagascar.

Sadly, the wonder generated by the night sky might prove to be scarcer and scarcer over time. Even from outer space, the persistent haze generated by light pollution is seen as a visible blanket shrouding the planet. It is possible that within a couple of decades, the sights that many of us have been able to enjoy on a clear night will no longer be viewable. Pristine sky-watching conditions, which have diminished significantly in the last century, may simply become a thing of the past—making the images in this book even more poignant and awe-inspiring.

Astronomer Carl Sagan evocatively noted the persistence of humanity's most ancient hobby: "Before we invented civilization, our ancestors lived mainly in the open out under the sky. Before we devised artificial lights and atmospheric pollution and modern forms of nocturnal entertainment, we watched the stars. There were practical calendar reasons, of course, but there was more to it than that. Even today the most jaded city dweller can be unexpectedly moved upon encountering a clear night sky studded with thousands of twinkling stars. When it happens to me after all these years, it still takes my breath away."

# PHOTOGRAPHS FROM

THE ARCHIVES OF NASA

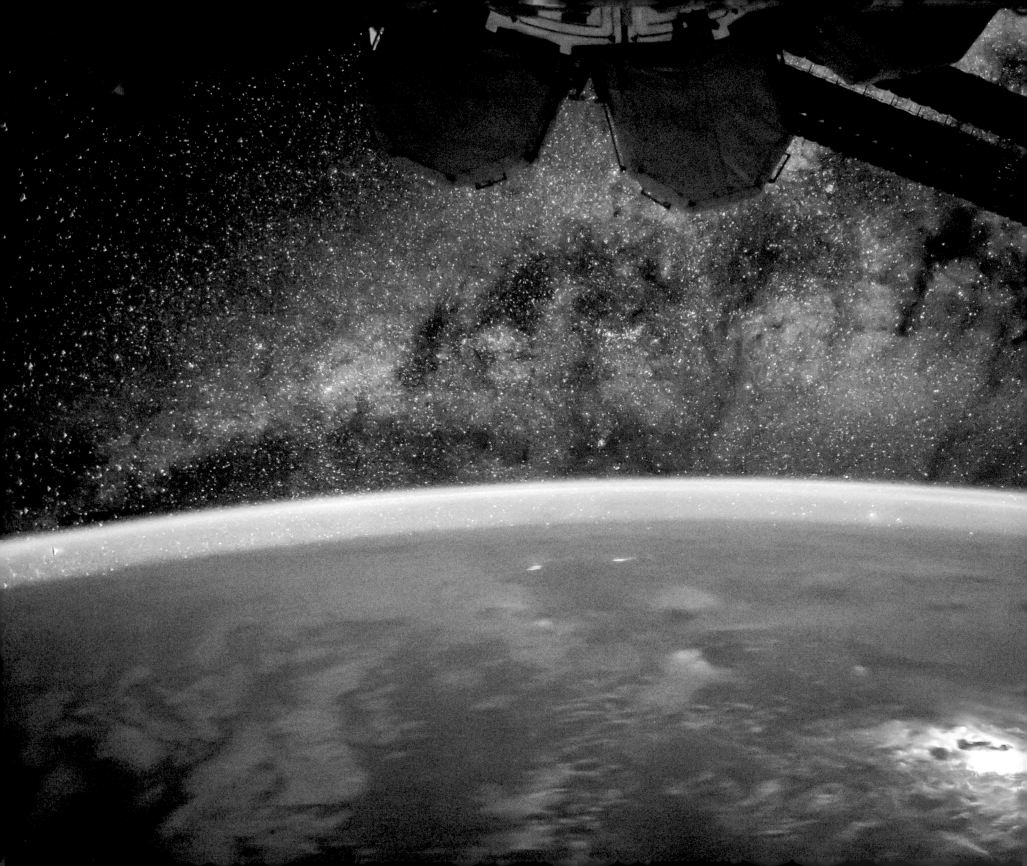

## STARGAZING FROM THE ISS

This panoramic digital image of the Milky Way's dense star field was captured by Expedition 44 crew members aboard the ISS. In a 24-hour period, the ISS experiences 16 orbits around Earth. In this image, it looms above the central equatorial Pacific, where dense clouds cover almost the entire surface of the ocean. The bright spot toward the bottom right corner is lightning illuminated through clouds; this light bounced off the solar arrays of the ISS, and from there, to the camera. The mottled dark areas in the star field are dust clouds that hinder a clear view of the stars toward the center of the Milky Way.

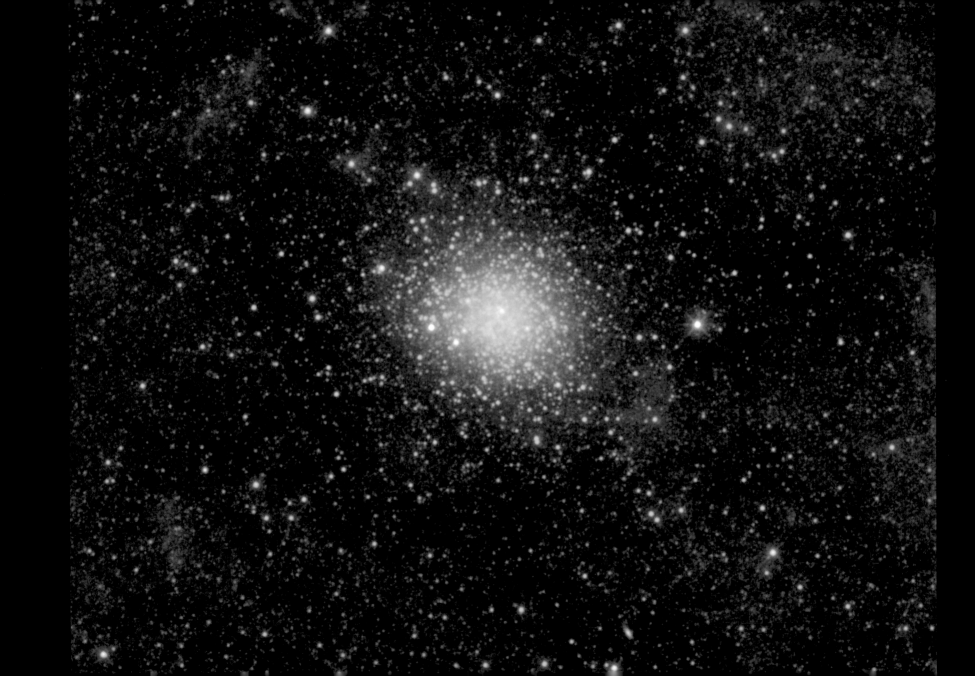

## < OMEGA CENTAURI

Omega Centauri, a cluster of stars in the constellation Centaurus, is the Milky Way's largest, most radiant globular cluster of stars and is visible in the southern half of the United States, seen most clearly in the evening sky in late April, May, and June. In the Southern Hemisphere, Omega Centauri is much higher and brighter in the sky. A globular cluster tends to be symmetrical and round in appearance, and it is home to anywhere from tens of thousands to millions of stars that are bound together by their gravity. This cluster is outside the galactic disk, 16,000 to 18,000 light-years away from Earth. It is one of the few globular clusters in the Milky Way that is visible to the naked eye.

## > SAGITTARIUS A*

This image features the dense, starry nucleus of the Milky Way near the constellation Sagittarius. Beyond these crowded pockets of stars, however, is a phenomenon that can't be found in this image: a black hole known as Sagittarius A*, roughly 4 million times the mass of our Sun and 26,000 light-years from Earth. It's one of the few black holes in our known universe into which astronomers have observed the flow of nearby matter. Astronomers have also detected stars spinning around the black hole as it swallows clouds of surrounding dust. It's believed that less than 1 percent of the material impacted by the black hole's gravitational pull reaches the event horizon (or point of no return), since much of it is ejected before that point. This image is the most detailed one that the Hubble's Wide Field Camera 3 has ever taken of this particular region of the galaxy.

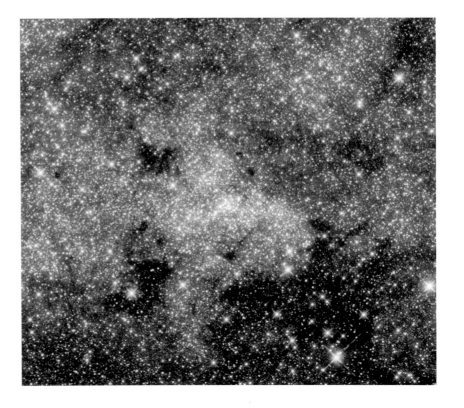

# A BURST BUBBLE

This false-color image of the emission nebula RCW 79 was captured by NASA's Spitzer Space Telescope. An emission nebula is a dense cloud of ionized gas that emits light at various wavelengths. RCW 79 is about 70 light-years across and 17,200 light-years away from Earth, in the constellation Centaurus. The nebula has continued to expand, resulting in new star formation, as well as large plumes of gas and dust flowing out into interstellar space. This infrared image shows clusters of new stars, which appear as yellowish points around the edge of the nebula. The bright "bubble" on the lower left edge also features an area of star formation. These stars emit ultraviolet light, which continues to excite dust within the bubble and makes it glow bright red in the infrared image.

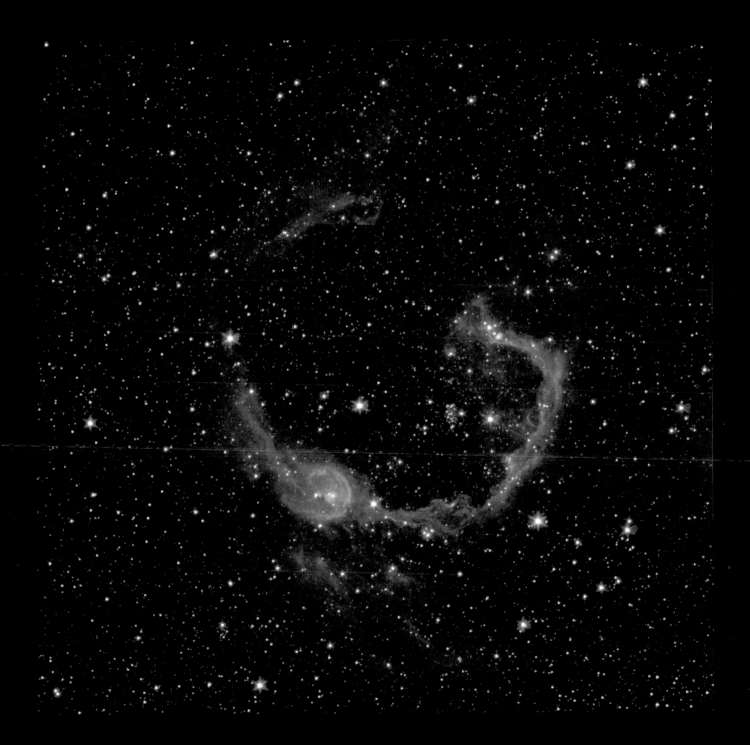

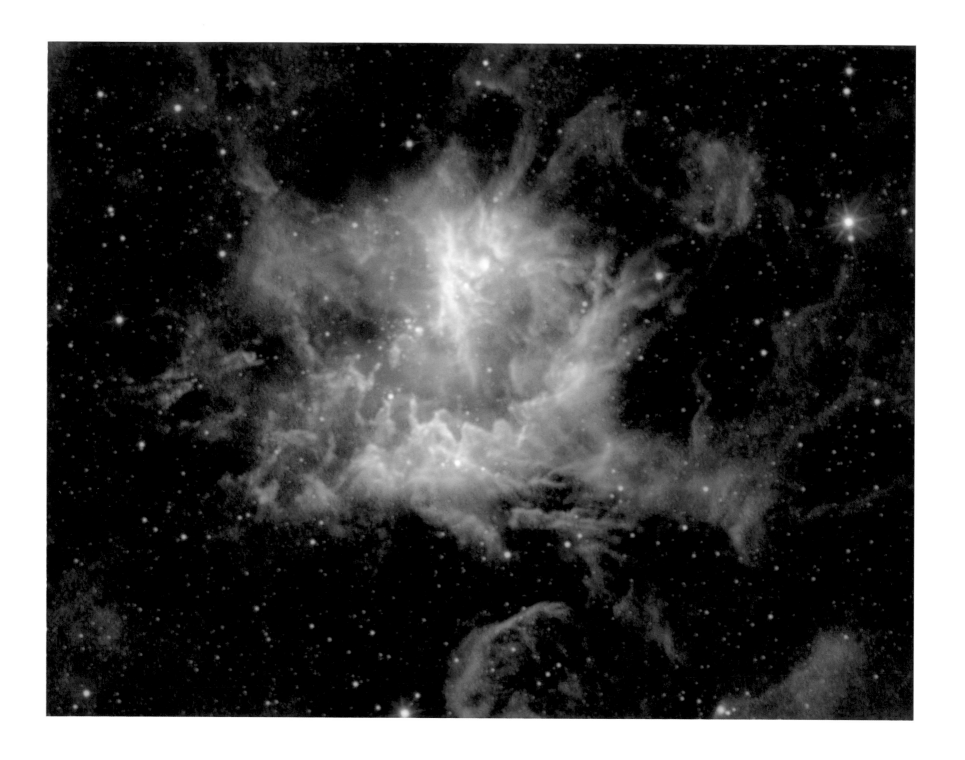

## PACMAN NEBULA

NGC 281 is a star-forming nebula in the constellation Cassiopeia, 9,200 light-years from Earth in the Perseus spiral arm of the Milky Way. It's also known as the Pacman Nebula. (Although the mouth of the Pacman character looks dark in most images, it glows brightly in this infrared image.) The stars in the nebula are massive, and powerful hot winds flow from their surfaces and dissipate into interstellar space, producing enormous columns of gas and dust. Many of these stars will eventually explode into supernovas and provide the galaxy with raw material for new stars.

## SKIES OVER KIRUNA

This photograph captures the deep blue skies above the Esrange Space Center close to Kiruna, Sweden. This is where the NASA-funded Balloon Array for Radiation-Belt Relativistic Electron Losses launched six miniature balloons with scientific payloads. They went on to measure X-rays in the atmosphere near the North Pole and study the content of electrons in the Earth's ionosphere. The X-rays in the atmosphere are the result of electrons from the Van Allen belts, two zones of energetically charged particles that originate from the solar wind and surround Earth several thousand miles above the planet's surface. The vaguely visible green glow in the sky is an aurora.

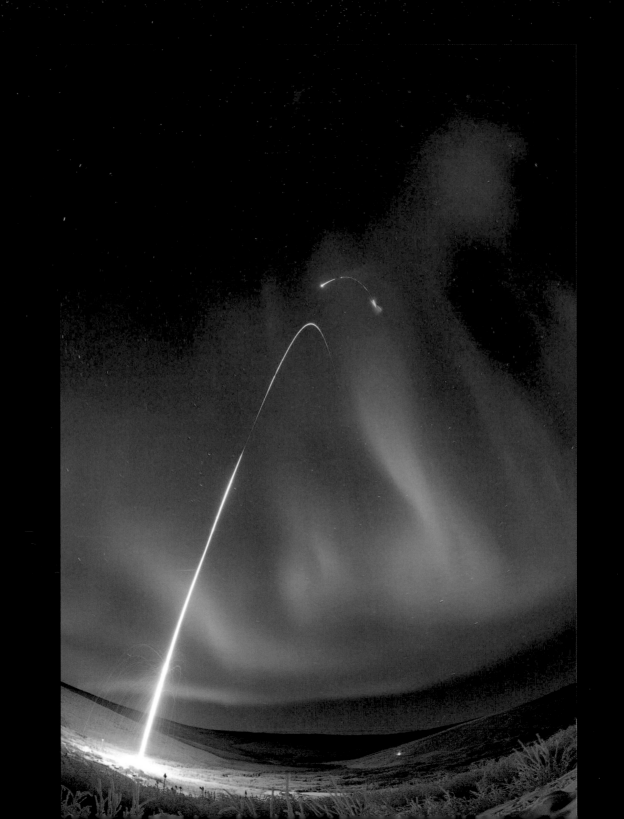

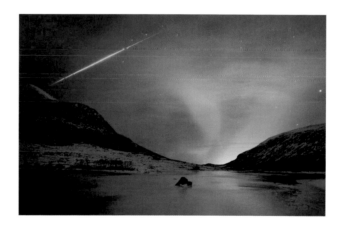

## ⟨ ORIOLE IV LAUNCHING INTO AN AURORA

This time-lapse image captures NASA's Oriole IV sounding rocket, which carried the payload for the Aural Spatial Structures Probe (ASSP). The ASSP studied how electric currents far up in the atmosphere, where auroras are generated, cause the atmosphere to expand. The ASSP experiment launched one massive instrument and six small probes that were ejected in midflight and created a picturesque formation dancing over the aurora in the background of this image.

## ⋀ GEMINID METEOR SHOWER

A spectacular Geminid meteor shower display accompanies the subtle shimmer of the aurora borealis in the skies above Norway. Every year in mid-December, Geminid meteoroids enter Earth's atmosphere at about 78,000 miles (125,530 kilometers) per hour, glowing in an array of colors. As many as one hundred shooting stars an hour have been sighted in ideal clear-sky conditions. Avid stargazers often prefer the Geminids to other meteor showers because the debris stream tends to be much bigger. The meteoroids originate from an extinct comet known as 3200 Phaethon, the remnant of a comet whose ice was gradually stripped away after it flew too close to the Sun.

## AIRGLOW

Airglow was discovered in 1868 by Swedish physicist Anders Ångström, who was originally interested in studying the aurora borealis. While auroras occur sporadically, he noticed that the upper atmosphere of the planet is consistently radiant. Auroras are caused by electrons interacting with the magnetic field of the planet close to the poles, while airglow occurs when particles in the upper atmosphere collide with sunlight and solar radiation roughly 60 miles (97 kilometers) above the surface of Earth. The particles then release photons, creating a blanket of light at the atmosphere's edge. There are three different levels of airglow: dayglow (when sunlight lights up the atmosphere), twilightglow (a narrow band of light generated as the face of Earth moves away from the Sun), and nightglow (when solar radiation causes particles of oxygen and nitrogen in the upper atmosphere to break down). Airglow is vivid from space, but it's much more difficult to see on the ground, as it's a billion times fainter than sunlight.

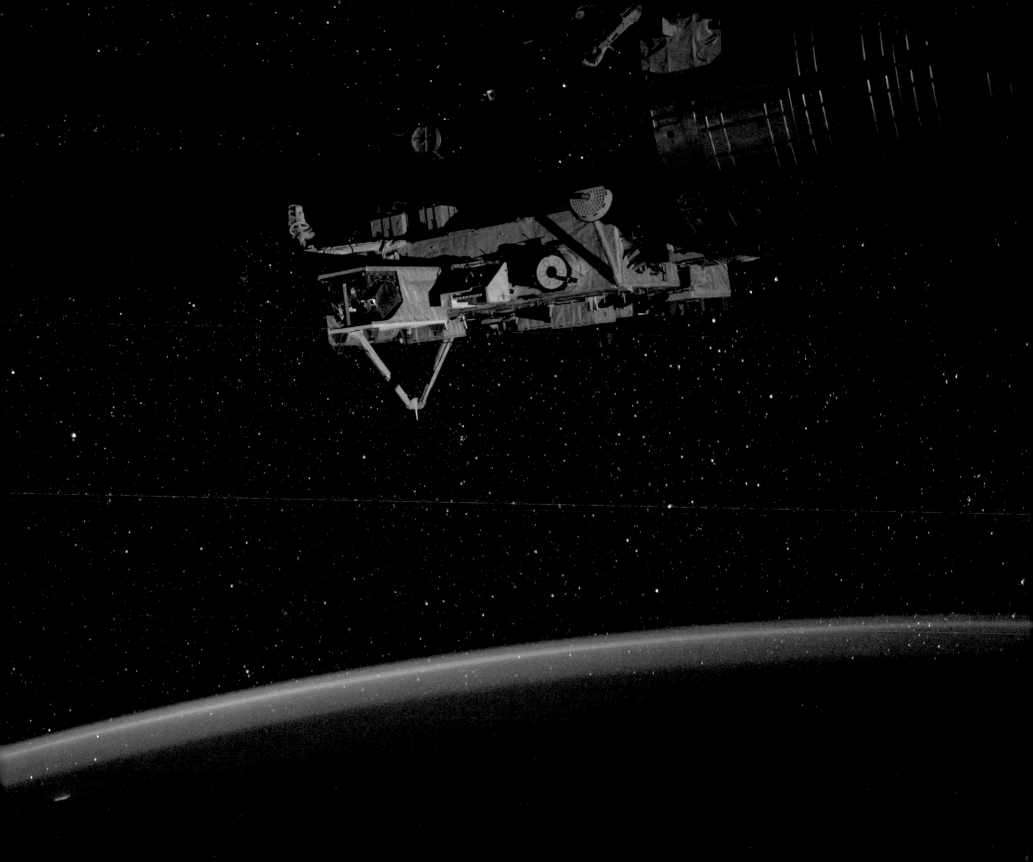

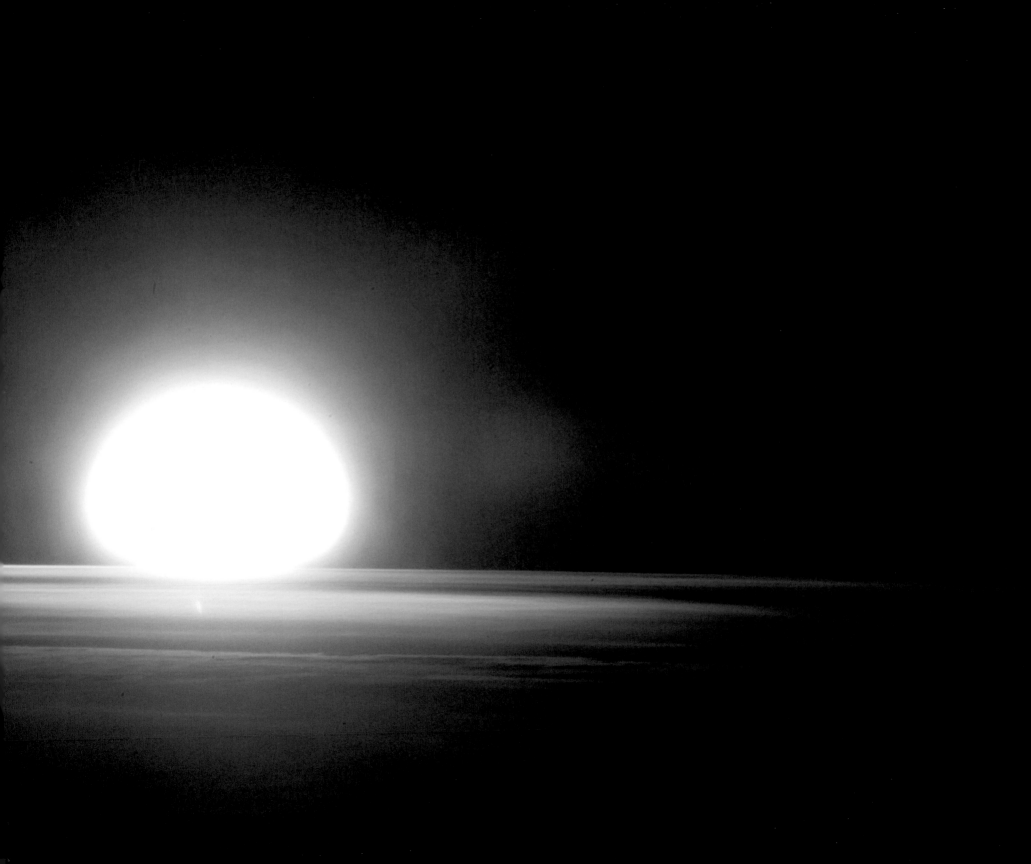

## THE UPPER ATMOSPHERE

This spectacular image of the Sun reveals the layers of Earth's upper atmosphere. The ionosphere is the part of the atmosphere that contains highly charged particles and acts as the boundary between Earth and space. It's challenging to observe, but we know that it responds to both weather patterns lower in the atmosphere and "space weather," including solar storms and flurries of energized particles from various cosmic phenomena. The upper atmosphere can undergo dramatic fluctuations quite frequently over the course of a mere hour.

## COMET LOVEJOY OVER
## THE SOUTHERN HEMISPHERE

NASA astronaut Dan Burbank of Expedition 30 took this image of Comet Lovejoy as it orbited just above the Southern Hemisphere after flying by the Sun. The colorful halo close to the atmosphere is the result of Earth's atmosphere distorting light from the Sun in an effect known as airglow. Airglow keeps the night sky from being completely dark when seen from Earth.

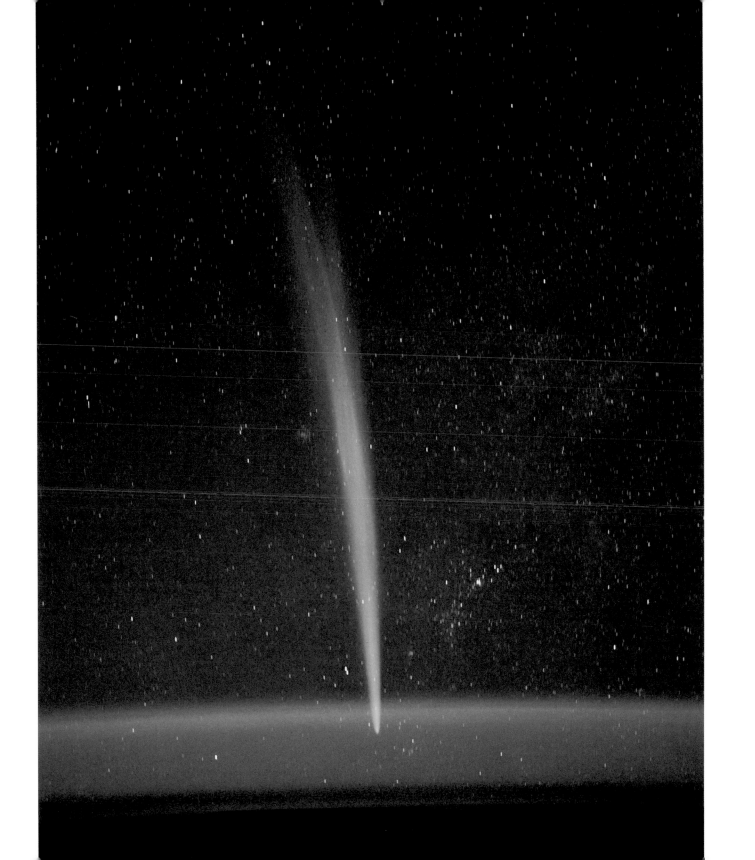

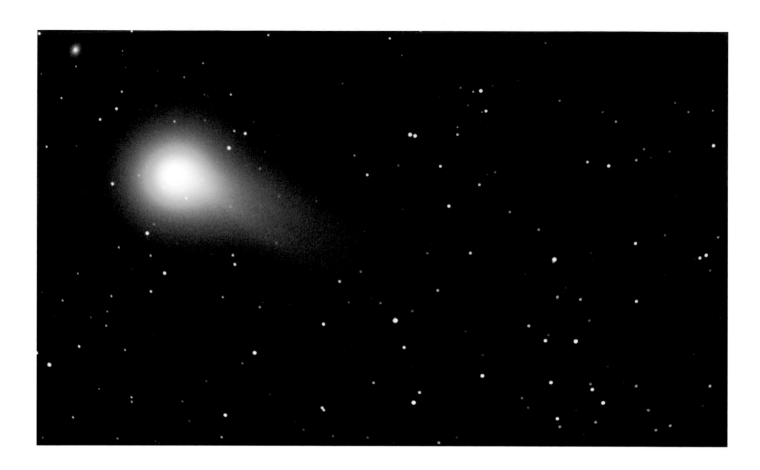

## COMET LOVEJOY FROM 37 MILLION MILES AWAY

Comet Lovejoy lives in the distant constellation of Ursa Major. Although seeing it requires a good pair of binoculars, this three-minute exposure offers a bright view. At this point, the comet was roughly 37 million miles (59.5 million kilometers) away from Earth, not far from its closest approach to the Sun. It survived that journey and also passed close to the Sun a little over two years later, when it released water at 20 tons (18 metric tons) per second. Although the majority of comets orbit far from the Sun, gravitational disturbances can send comets closer in, where they will then heat up and release gases.

## COMET LOVEJOY FROM THE ISS

This image of Comet Lovejoy was captured by astronauts aboard the ISS. Comet Lovejoy belongs to a grouping of comets called Kreutz sungrazers, believed to have been fragments of a larger comet that disintegrated several centuries ago. Sungrazers' orbits carry them close to the Sun, and radiation and the solar wind dance with the comets' nuclei to create colorful, dramatic displays.

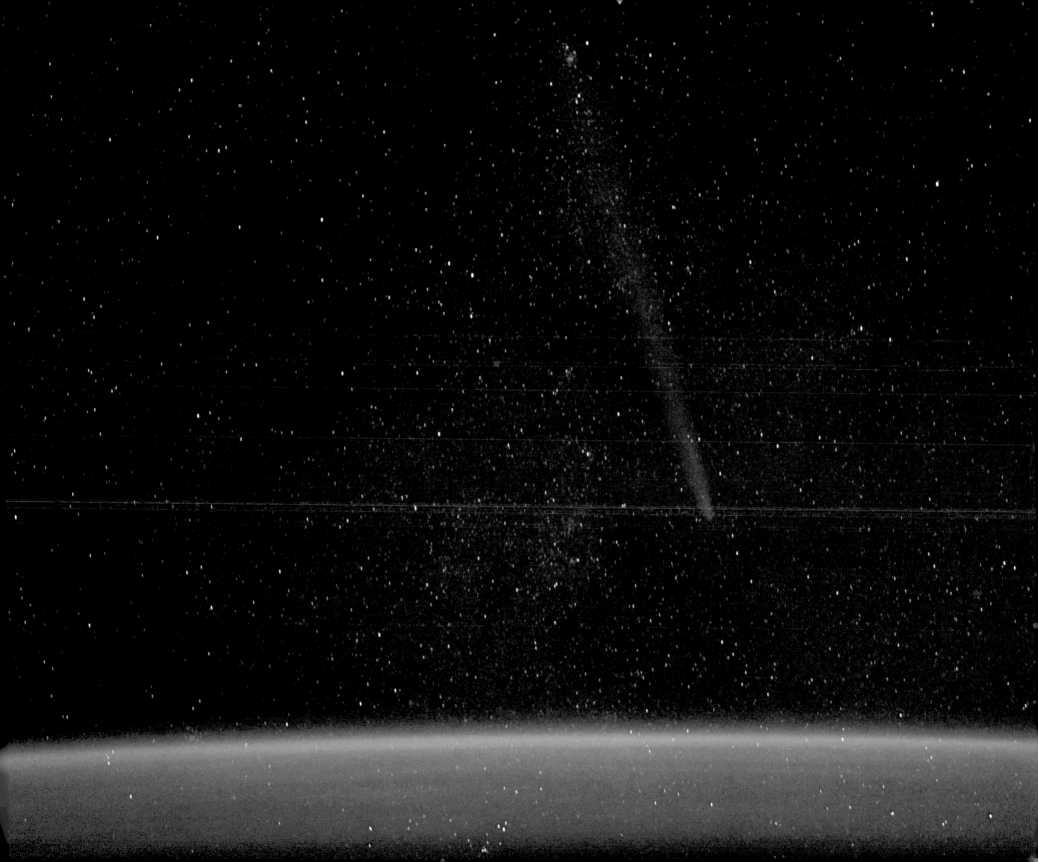

## COMET LOVEJOY FROM 40 MILLION MILES AWAY

This image of Comet Lovejoy was taken on November 26, 2013, when the world was awaiting the arrival of Comet ISON in the vicinity of the Sun. Although Lovejoy was 40 million miles (64.4 million kilometers) from Earth at this time, it provided an impressive spectacle for avid sky-watchers, with its prominent tail and radiant green coma (the gaseous envelope around the central body of the comet, which develops as a comet nears the Sun). Lovejoy is well known for its release of copious amounts of alcohol and sugar, which might link it to the genesis of the complex organic molecules that made life on our planet possible.

## COMET PANSTARRS

On March 12, 2013, scientist Aaron Kingery captured this image of Comet PanSTARRS (visible as a bright spot in the middle left) as it approached maximum brightness while moving across the evening sky. The comet had already made its orbit around the Sun two days prior, before gradually swinging beyond Earth's orbit. It won't be visible for another 100,000 years, and scientists believe that it takes over 100 million years to orbit the Sun.

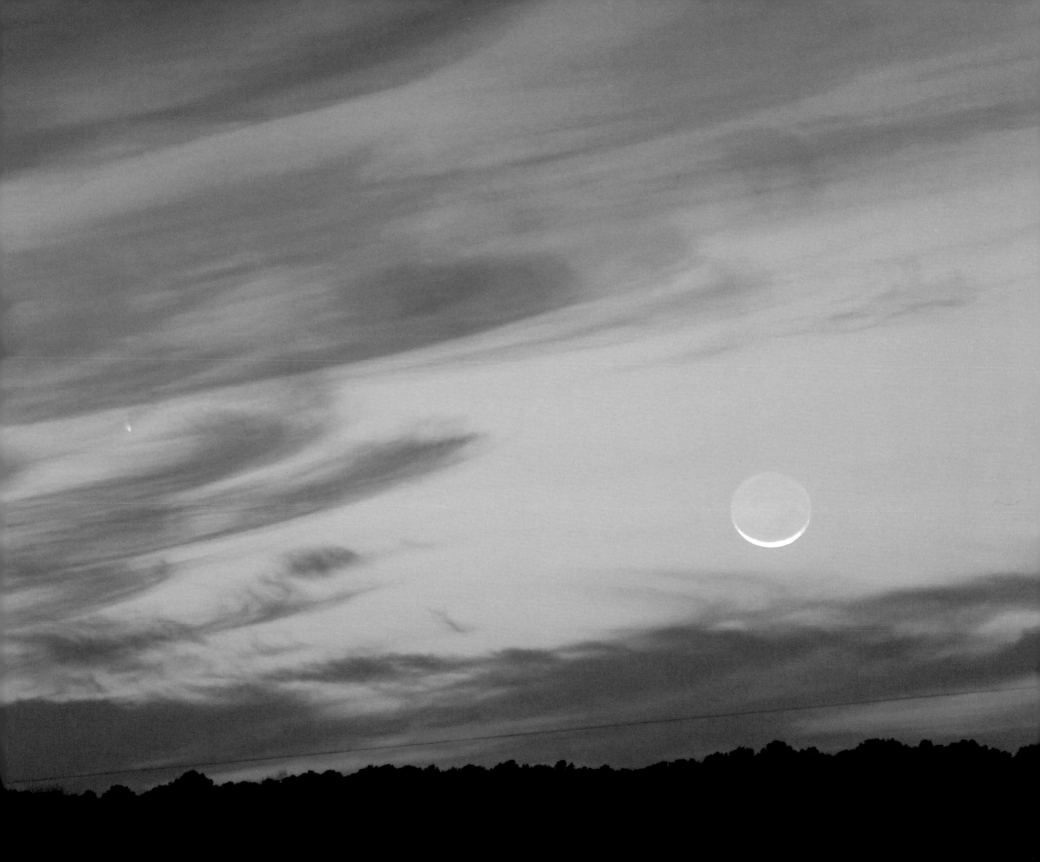

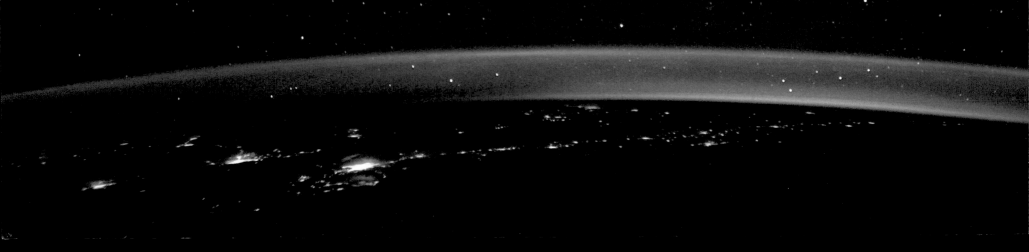

## COMET LOVEJOY OVER CHILE

One of the Expedition 30 crew members aboard the ISS captured this image above the Chilean coast at night, facing southeast. The image also features Comet Lovejoy (right of center) streaking through space. ISS crew members are accustomed to seeing the comet close to Earth's horizon at night, where it appeared as a long glowing arc. This is quite different from how Comet Lovejoy looks on the ground, due to the presence of Earth's intervening atmosphere.

## CYGNUS BURNING IN EARTH'S ATMOSPHERE

The unmanned Cygnus cargo carrier returns from a resupply mission to the ISS and disintegrates in Earth's atmosphere above the Pacific Ocean. Objects burn up in Earth's atmosphere when they are re-entering at a high speed; large objects in particular experience a compression of air toward the front, which generates intense heat—often causing the object to disintegrate well before it gets to the lower levels of Earth's atmosphere. The remaining debris often also burns up before reaching the ground. In this case, the destruction of the high-speed carrier was intentional. Shuttles with crew members typically include heat-resistant tiles on the craft's bottom, which prevent burning upon re-entry into Earth's atmosphere.

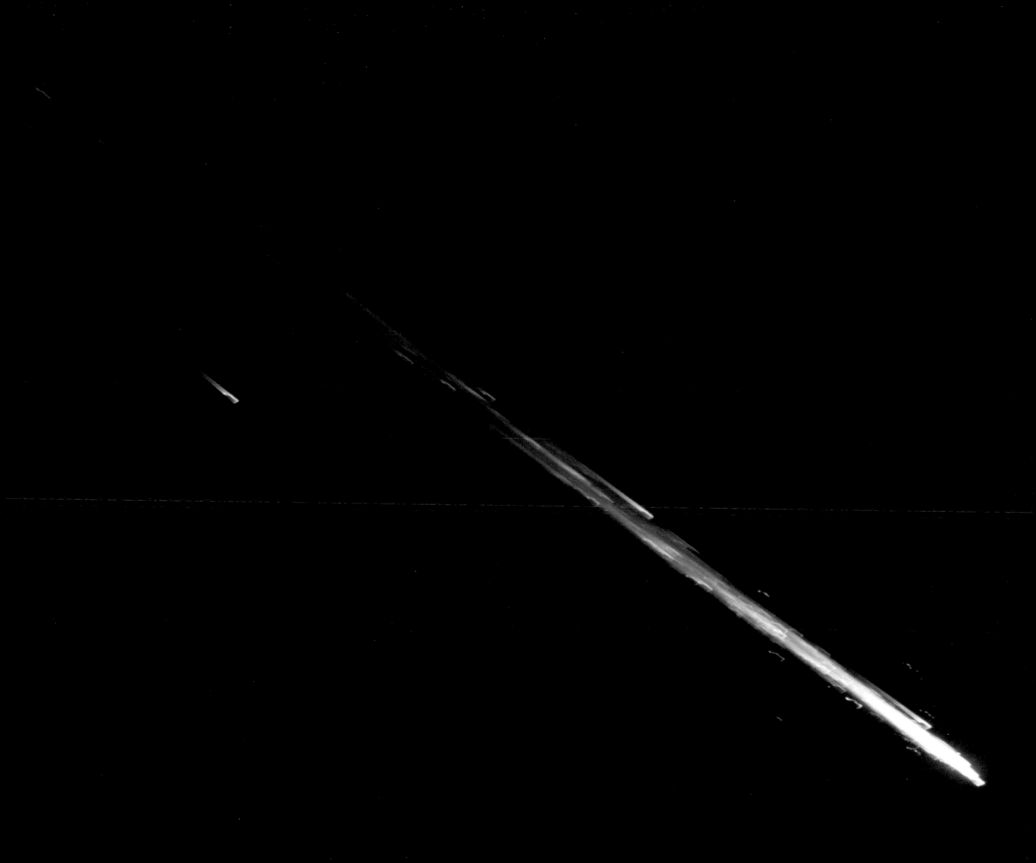

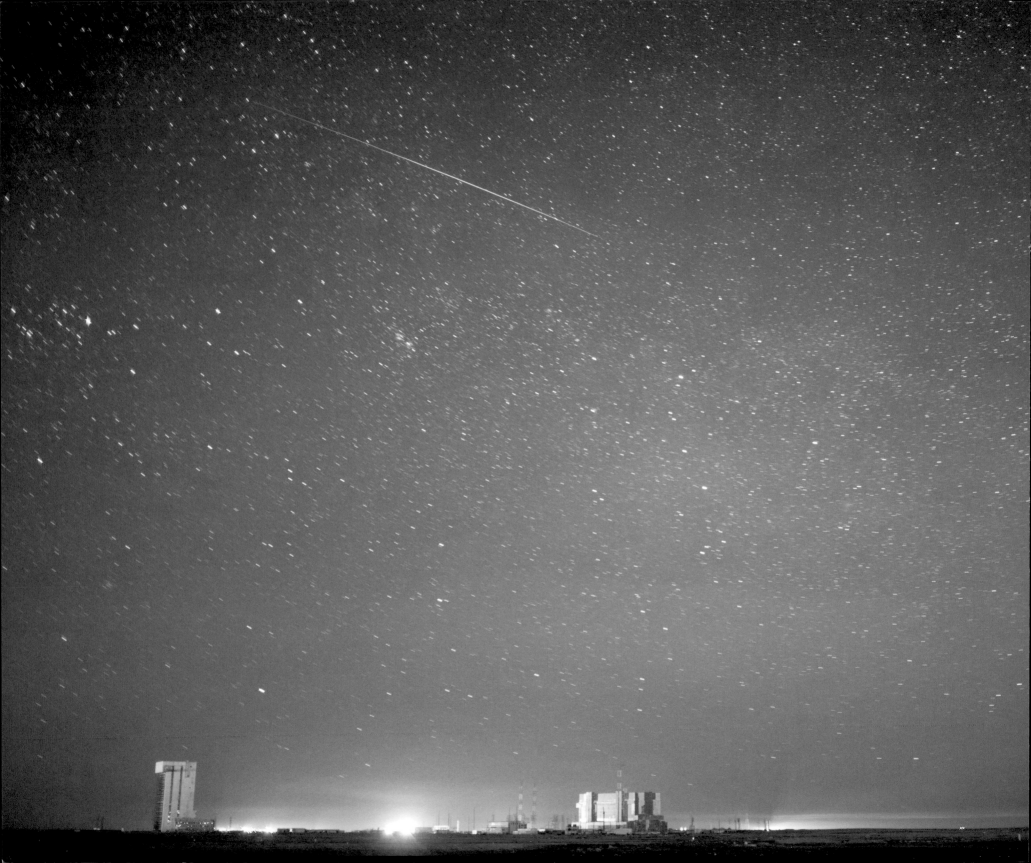

## EXPEDITION SOYUZ MEETS A METEOR

A meteor graces the skies above Kazakhstan as the Soyuz TMA-19M space-craft prepares to launch from the Baikonur Cosmodrome. The spacecraft sent Commander Yuri Malenchenko of the Russian Federal Space Agency, Flight Engineer Tim Kopra of NASA, and Flight Engineer Tim Peake of the European Space Agency to the ISS for six months. In order to get into orbit, the spacecraft had to amp up its velocity to 17,200 miles (27,680 kilometers) per hour, which is the same speed at which it re-entered Earth's atmosphere. As it approached the ISS, Soyuz's automatic docking system failed, forcing Malenchenko to manually dock the spacecraft.

# SPACE SHUTTLE *ENDEAVOUR* LIFTOFF FROM A DISTANCE

In this stunning image, the Space Shuttle *Endeavour* moves toward Earth's orbit to link up with the ISS. This was the *Endeavour*'s 19th launch and 112th flight in the shuttle program. During the 14-day mission, *Endeavour* transported more than 2,500 pounds (1,134 kilograms) of material to the ISS

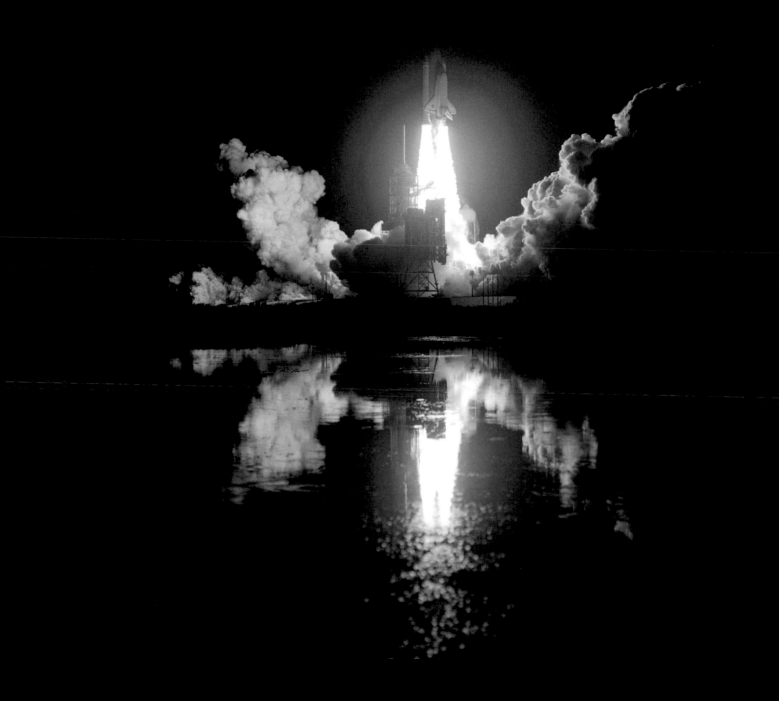

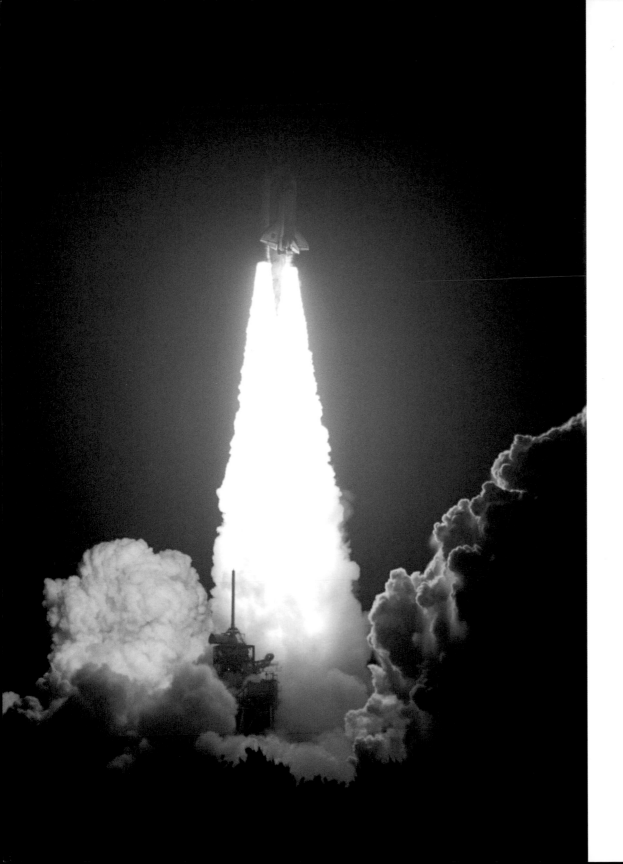

< **SPACE SHUTTLE *ENDEAVOUR* LIFTOFF UP CLOSE**

Space Shuttle *Endeavour* lifts off and moves toward Earth's orbit from the Kennedy Space Center. *Endeavour* was actually partially responsible for birthing the ISS; its December 1998 mission brought the ISS its first American unit (the passageway between the working and living modules) and connected it to the Russian Zarya module.

>

## CONTOUR

A Boeing Delta rocket races across the sky, carrying the spacecraft CONTOUR. CONTOUR was launched to study the chemical composition of two comets, Encke and 73P/Schwassman-Wachmann-3, as they entered the inner solar system. Encke is a periodic comet that orbits the sun every 3.3 years, while 73P/Schwassman-Wachmann-3 is also a periodic comet but is in the process of disintegrating. Sadly, an engine burn caused the spacecraft to disintegrate shortly before it was to have been propelled beyond Earth's orbit.

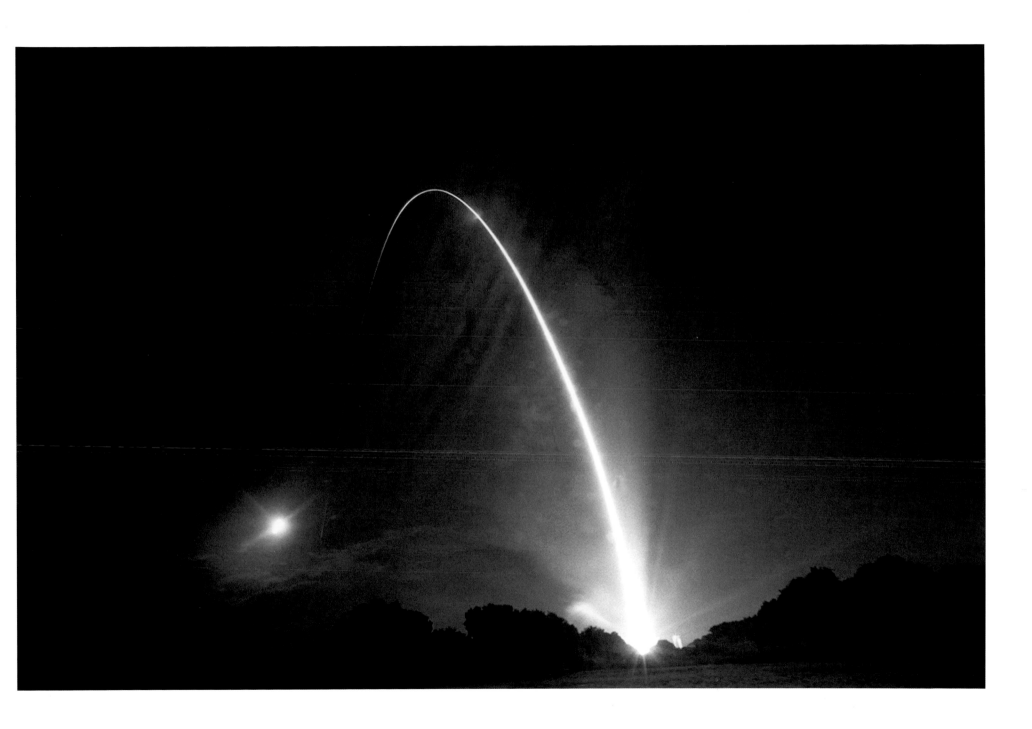

## NIGHT FLIGHT

On August 30, 1983, the space shuttle *Challenger* launched into the night sky for its third flight into space, carrying the STS-8 crew: Commander Richard Truly, pilot Daniel Brandenstein, and mission specialists Dale Gardner, Guy Bluford, and William Thornton. Notably, Bluford was the first African American in space. *Challenger*'s orbiter, a space plane released into orbit around Earth, was dropped to an altitude of 139 miles (224 kilometers) to perform tests on thin atomic oxygen, while the shuttle's Animal Enclosure Module studied six rats to determine how animals react in space. Sadly, during a later launch on January 28, 1986, *Challenger*'s crew members were killed when the failure of a booster engine took the shuttle down 73 seconds after its launch.

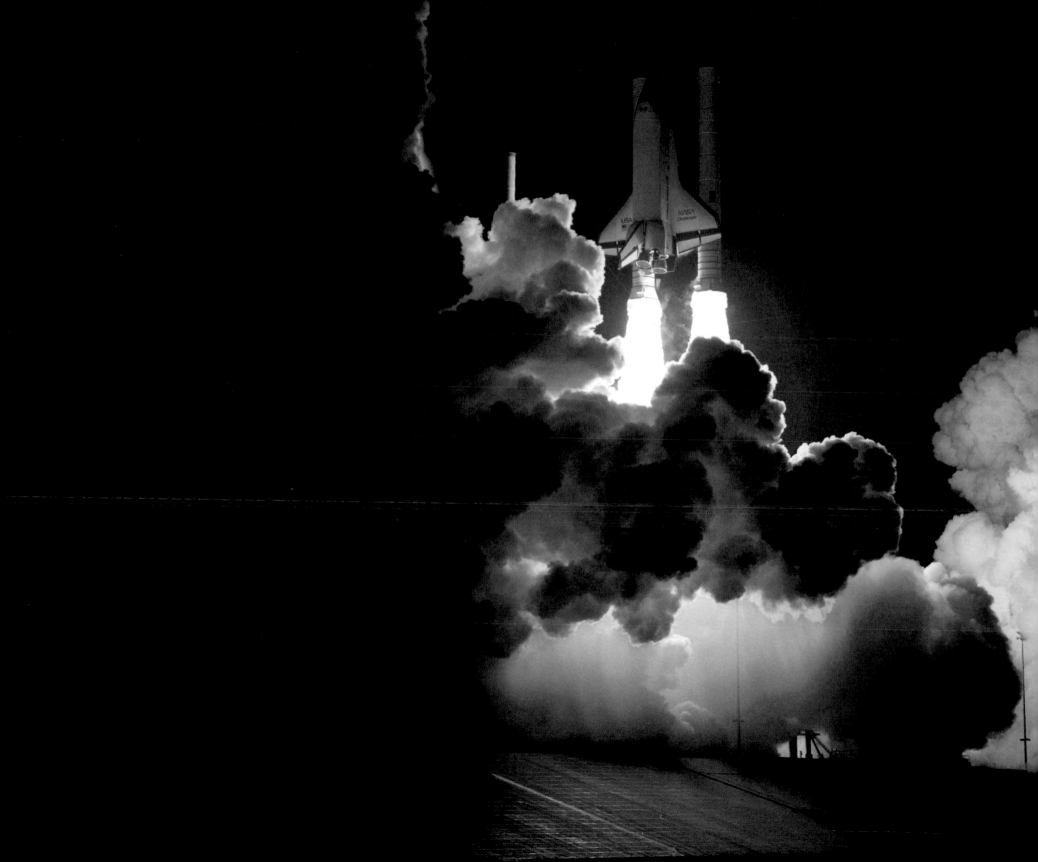

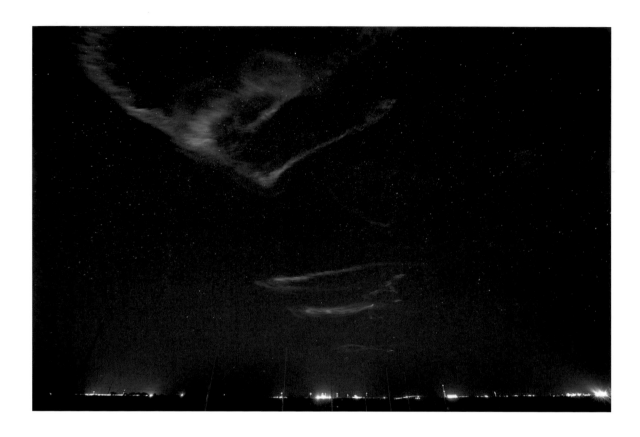

## TRAILS OF JET STREAMS

These ghostly images of jet stream trails were taken in March 2012, when NASA launched five sounding rockets from Wallops Flight Facility in Virginia into the upper atmosphere. The rockets examined the connection between high-altitude winds and electrical current patterns around the planet. Knowledge of this connection allowed scientists to better understand how atmospheric disturbances can impact human-made satellites and communications systems. Sounding rockets are only in the sky for eight to ten minutes, but they help scientists study hard-to-reach layers of Earth's atmosphere, roughly 60 to 65 miles (97 to 105 kilometers) above the planet's surface. While in the air, these rockets released the chemical trimethyl aluminum, which formed milky white clouds and made the jet streams visible to observers on the ground for 20 minutes after the rockets launched.

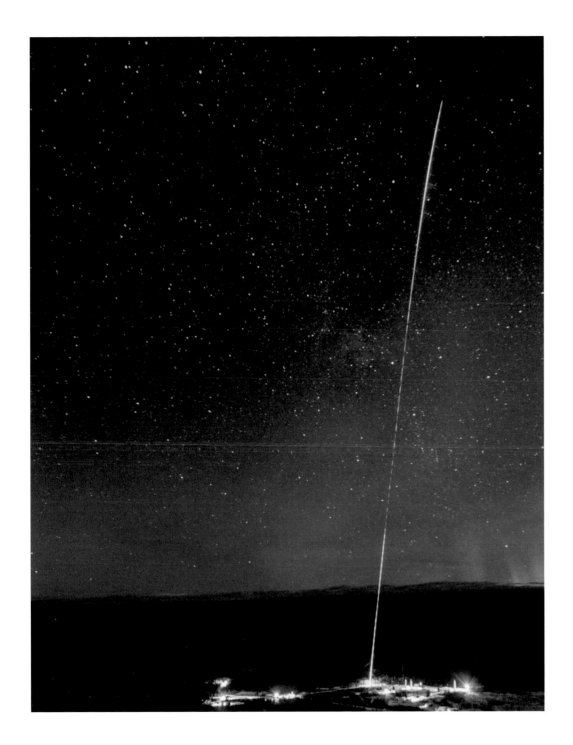

## ROCKETS FLYING THROUGH ACTIVE AURORAS

In February 2017, NASA launched five test rockets from Alaska's Poker Flat Research Range. The rockets were launched into active auroras to study Earth's magnetosphere (the area surrounding a planet and its magnetic field, formed by the interaction between the solar wind and the planet's magnetic field) and its effects on the upper atmosphere. The aurora is the final step in a chain of processes that links the solar wind to our atmosphere. Scientists sought to understand the electrodynamics of processes high up in the atmosphere, as well as the "neutral jets," which are winds carrying electrically neutralized atoms, which the ionosphere generates within an aurora's arc.

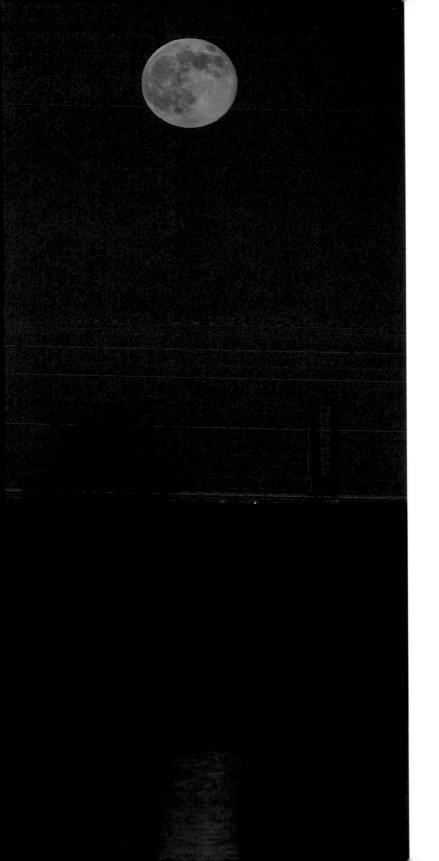

## ANTARES ROCKET AND A FULL MOON

A full Moon appears alongside the Orbital Sciences Corporation Antares rocket (left of Moon), which was carrying the Cygnus spacecraft. The spacecraft was loaded down with provisions for crew members aboard the ISS. The reddish-orange Moon was actually a supermoon because it occurred during the Moon's perigee (its closest approach to Earth). Lunar eclipses often render the Moon red, but the Moon can also assume an orange or red tint when it is close to the horizon. When light approaches Earth, it scatters off of atoms and molecules in the atmosphere. These particles tend to scatter blue light more so than red light; this is why cosmic objects appear redder on Earth than they do in space. The Sun and Moon look especially red while rising or setting, because these are the moments when light has to travel through the most atmosphere—scattering more blue light in the process and allowing more red light to enter.

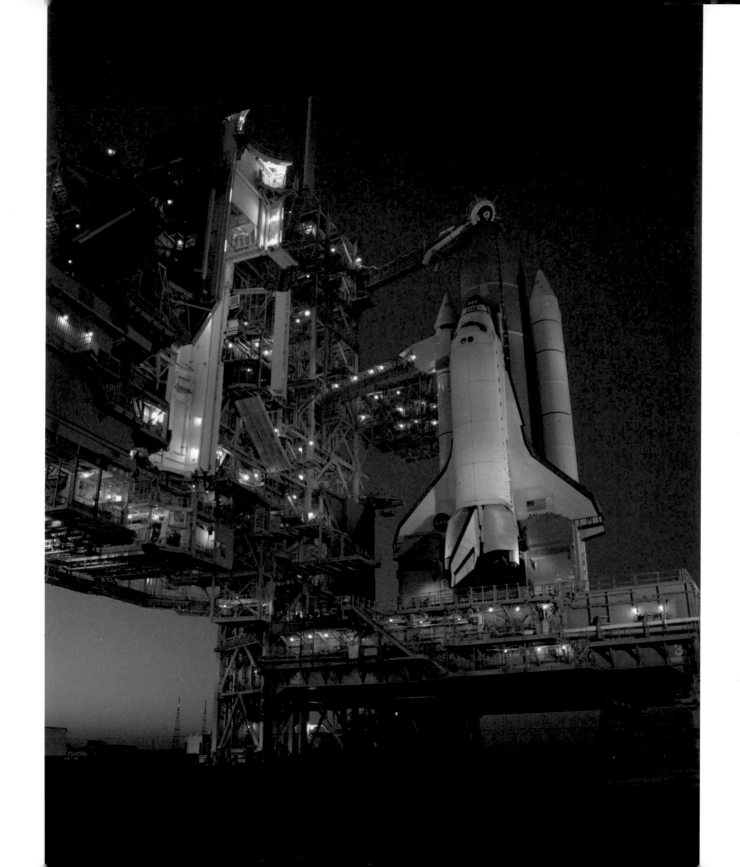

## < SPACE SHUTTLE *ATLANTIS*

On November 16, 2009, the Space Shuttle *Atlantis* prepared to launch from NASA's Kennedy Space Center in Florida. The STS-129 mission to the ISS delivered numerous pieces of equipment, including two spare gyroscopes, two nitrogen tanks, and material for the robotic arm of the ISS. The mission also came back home with crew member Nicole Stott, who was on the ISS's orbiting laboratory for over two months. *Atlantis* is known for being the first space shuttle to launch an interplanetary probe, Magellan, which mapped over 98 percent of the surface of Venus. It also launched the Galileo probe, which studied Jupiter and even captured close-up images of an asteroid heading toward the planet. *Atlantis* made the only direct observations of a comet crashing into a planet, when Shoemaker-Levy 9 collided with Jupiter in 1994. It was also the last space shuttle to visit the Hubble Space Telescope; it made important repairs and added equipment that would allow the telescope to pick up ultraviolet data and also better observe dark matter and energy.

## > SPACE SHUTTLE *COLUMBIA*

This image captures the launch of Space Shuttle *Columbia* on July 23, 1999, after two unsuccessful launch attempts on previous nights. The space shuttle's five-day mission released the Chandra X-Ray Observatory, a satellite with a 64-hour orbit around Earth. Chandra, like Hubble, observes some of the most distant cosmic phenomena we know of. *Columbia*'s Commander Eileen M. Collins was the first woman to serve as commander of a space shuttle. Tragically, during its final mission in February 2003, *Columbia* disintegrated in the Earth's atmosphere over Texas, killing all seven crew members.

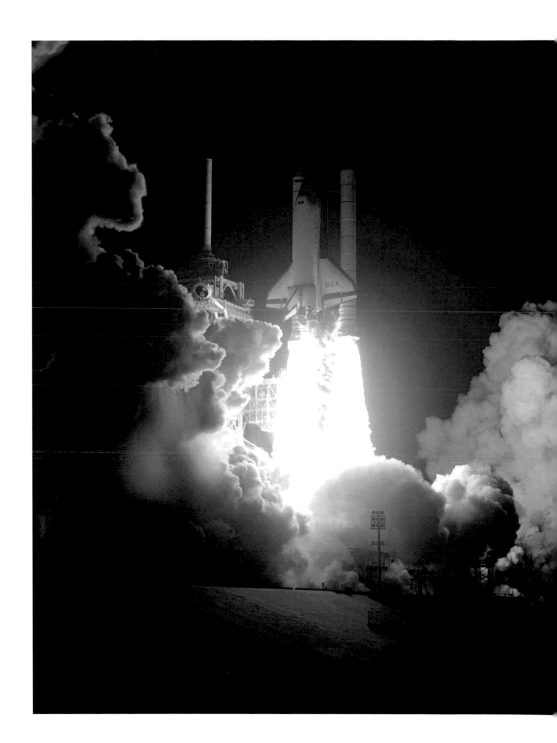

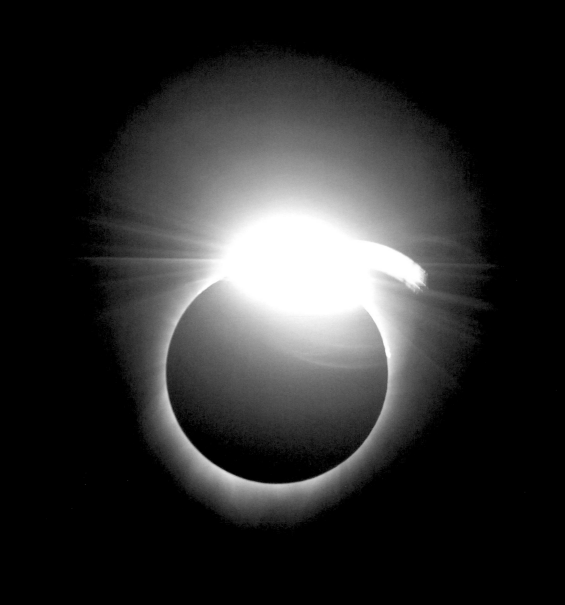

## A DIAMOND RING

This photo from the total solar eclipse on August 21, 2017, captures the "diamond ring" effect that appears during such events. The last remaining portion of sunlight during a total eclipse evokes the glow of a bright diamond, and, along with the first view of the thin ring of the Sun's corona, resembles a ring.

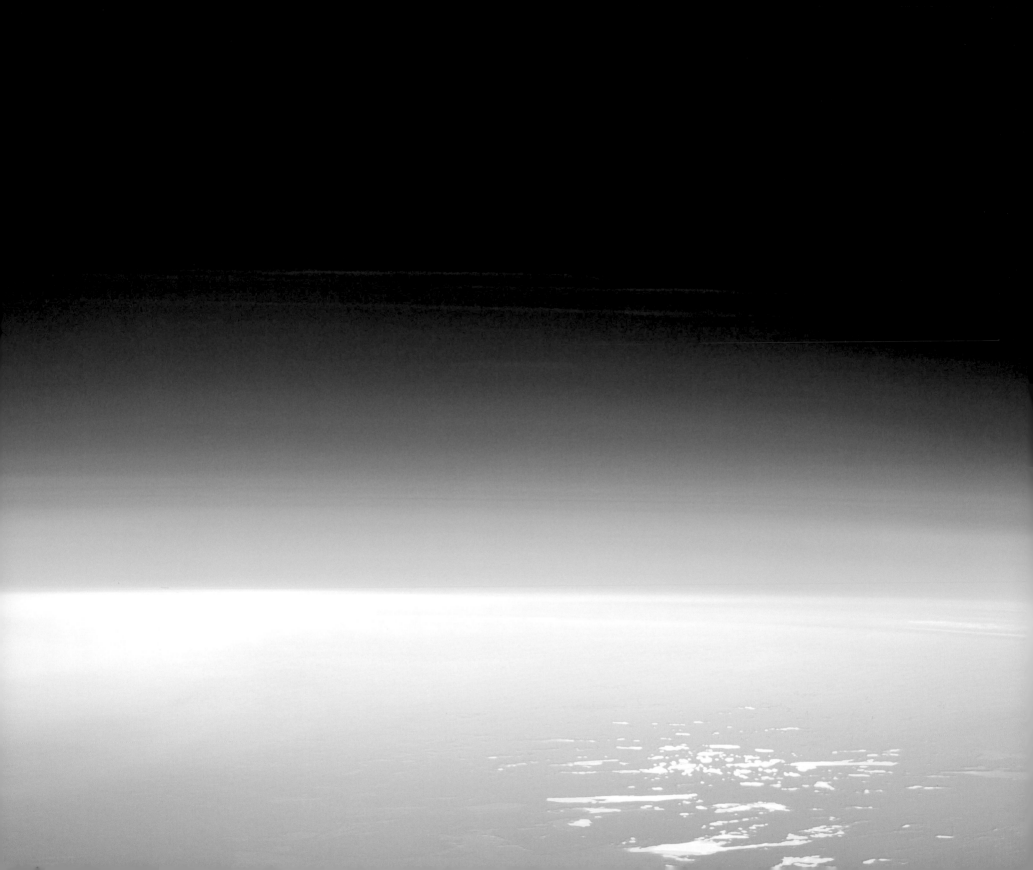

## < NOCTILUCENT CLOUDS 2016

This photo was taken by European Space Agency Flight Engineer Tim Peake aboard the ISS. The dark clouds are high altitude noctilucent or "night-shining" clouds, which are illuminated when the Sun is just below the horizon and the sky appears dark on the ground. Over the last three decades, satellite observations have shown noctilucent clouds occurring more frequently, and at lower altitudes. The source of the particles that allows the clouds to form is unknown. We know that noctilucent clouds form during the summer months, when the North Pole is perpetually flooded with sunlight. It's possible that warm air above the pole carries dust upward from the lower atmosphere, allowing water in the upper atmosphere to condense. It's also possible that the dust drops into the atmosphere from space. Many scientists believe that by studying Earth's noctilucent clouds, we can model high-altitude, low-density clouds that appear on other planets, such as Mars.

## ∧ NOCTILUCENT CLOUDS 2012

This ghostly image of the night sky was captured as the ISS transited over Tibet. Noctilucent clouds are typically visible at twilight as dancing waves. They are also known as polar mesospheric clouds, and they form at 47 to 53 miles (76 to 85 kilometers) above Earth's surface. That's just a few miles below the mesopause, which is the coldest region of the planet's atmosphere. At this altitude, water vapor freezes into ice crystals. Scientists in recent years have closely observed noctilucent clouds in relation to climate change, since fluctuations in the atmosphere are evident in the brightness and frequency of the clouds. Because the mesosphere has a low density and very cold temperatures, even the minutest changes in this region can reveal a lot about the atmosphere.

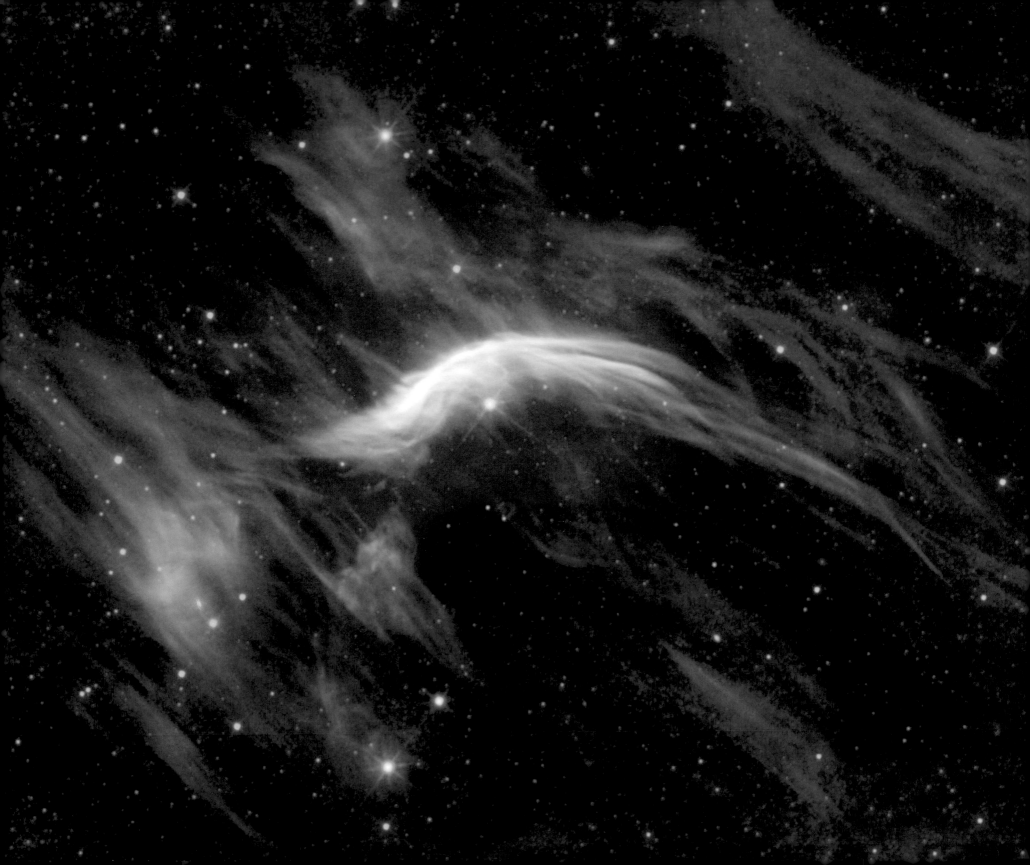

## ZETA OPHIUCHI

The blue star in the middle of this image is Zeta Ophiuchi, which is moving through an enormous cloud of gas and dust. Zeta Ophiuchi is believed to have once been part of a binary star system. When its partner died, Zeta Ophiuchi was suddenly free of the other star's gravitational field and rocketed out into space like a cannon. The star would be even brighter if it were not obscured by dust clouds. Stellar winds travel from this star at 54,000 miles (86,905 kilometers) an hour: speedy enough to break the sound barrier in the material around it. As winds flow out from the star, they ripple the dust around it, creating a bow shock that is only visible in infrared light. A bow shock is similar to a sonic boom, which can occur when an airplane or other fast-traveling vehicle moves faster than the speed of sound. The area around the bow shock ripples out at infrared wavelengths and creates an arc. The bow shock occurs when two different areas of gas and dust collide, one that is faster-moving and one that is slower. Our own Sun has fairly slow stellar winds, so it's unlikely to create a bow shock when it meets pockets of interstellar gas.

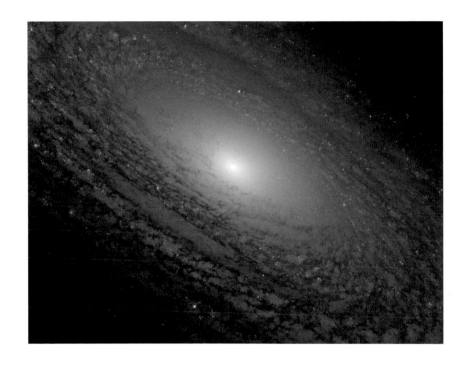

## < BRIGHT AURORA

This glowing image of an aurora was taken on the ISS by European Space Agency flight engineer Thomas Pesquet. Auroras occur when the electrons and protons in solar winds interact with our planet's magnetosphere. Oxygen and nitrogen molecules are stimulated, leading to a burst of photons, which are responsible for the northern and southern lights (the aurora borealis and the aurora australis, respectively) at the poles of Earth. Color variations are caused by varying levels of excitement, as well as the amount of oxygen and nitrogen molecules present. The undulating pattern that auroras assume is caused by the shape of Earth's magnetic field.

## ∧ STAR DISK

The spiral galaxy NGC 2841 is roughly 46 million light-years away in the constellation Ursa Major. Younger stars outline the spiral arms that extend outward from the bright galactic center. Notably, there are no areas harboring emission nebulae, which would be visible in pink. Emission nebulae are cradles for star formation, but it's likely that they were blown out of the galaxy by intense winds and radiation from hot, bright stars. NGC 2841 is a flocculent spiral galaxy, meaning that it has short spiral arms rather than prominent ones. We still don't know how new stars form in this type of galaxy.

# NOVA CENTAURI

The bright spot in the center of this massive star field is a nova (Latin for "new star"). Nova Centauri is located in the Centaurus constellation and most likely started off as a white dwarf in a binary star system. This image was captured with a one-minute exposure by the refracting telescope at Australia's Siding Spring Observatory. Although the star is usually a faint speck in the night sky, it is 10,000 times brighter than usual in this photo. This temporary effect, which lasted for a period of weeks, arose when matter from the other star in the system was blown off the surface of this star. Other observations of Nova Centauri were instrumental in helping astronomers understand the prevalence of lithium (one of the few elements that originated during the Big Bang) in novae, compared to older stars. Astronomers have speculated that the extra lithium in novae is likely the result of the stellar explosions, which also contribute to their temporary brightness. The majority of lithium in the universe is generated by novae.

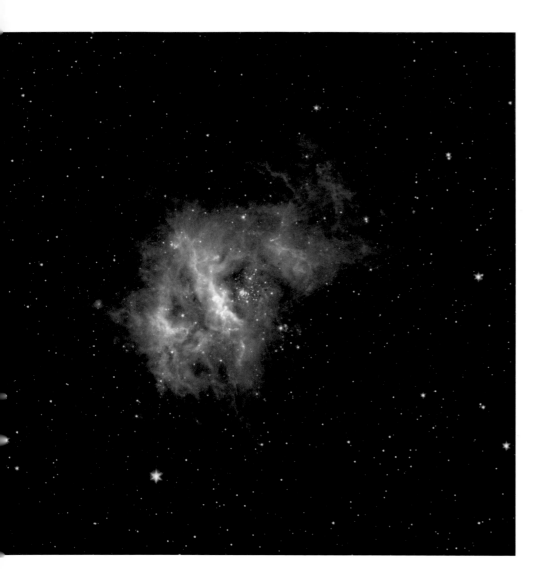

## < MILKY WAY FROM THE SPITZER

NASA's Spitzer Space Telescope captured this image of the nebula known as RCW 49, which can be found 13,700 light-years away in the constellation Centaurus. Most of the nebula's stars are not detectable in visible wavelengths because they are obscured by large columns of dust. This image shows some of the nebula's older stars in the central blue pocket, with gas filaments in green, and dusty tendrils in pink. The protostars in the dusty clouds of the nebula offer us a sense of how stars form in our own galaxy.

## > CEPHEUS B

This composite image draws on data from NASA's Chandra X-Ray Observatory and Spitzer Space Telescope. It features the molecular cloud Cepheus B, which resides about 2,400 light-years from Earth. A molecular cloud consists mostly of molecular hydrogen and is an area of cool interstellar gas and dust that are the remnants of galaxy formation. The bottom of the image features parts of the molecular cloud, while the areas in violet show young stars with prominent X-ray emissions. Recent studies suggest that the star formation in Cepheus B was activated by radiation from a massive star, known as HD 217086, just outside the molecular cloud. The radiation sent a compression wave into the dense cloud, evaporating its outer layers and enabling star formation in the interior.

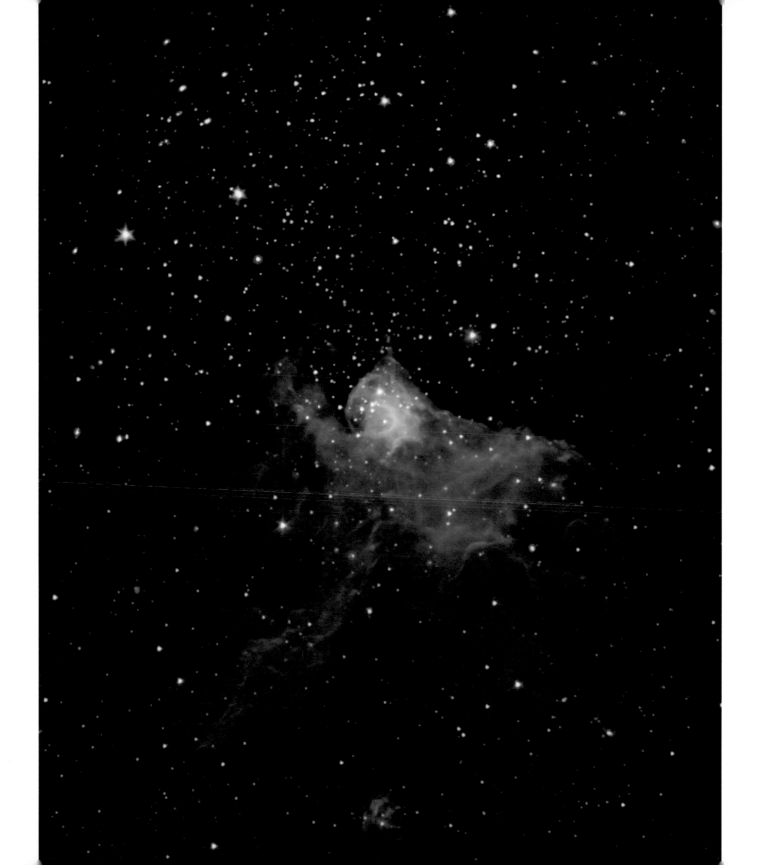

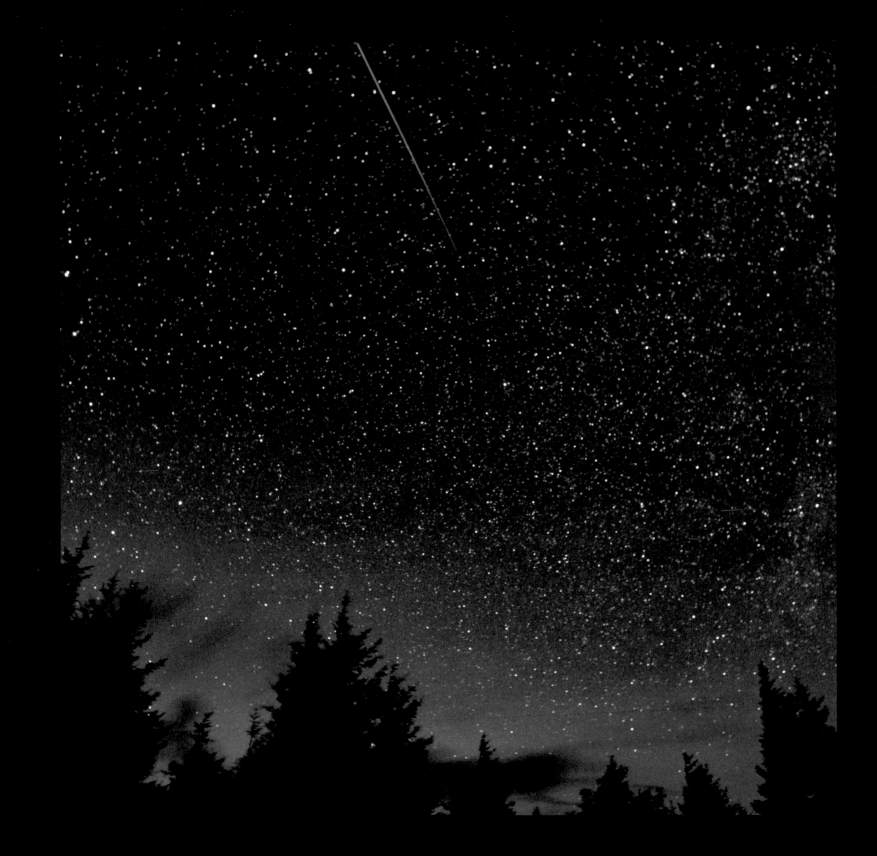

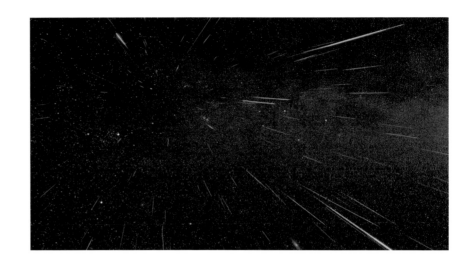

## < PERSEID SHOWER 2015

This is a 30-second exposure of the Perseid meteor shower over Spruce Knob, West Virginia. The Perseids make their appearance every August, when the Earth moves through the debris left in the wake of Comet Swift-Tuttle. The Perseid meteoroids swiftly enter the Earth's atmosphere (at which point they become known as meteors), traveling at 133,200 miles (214,360 kilometers) per hour. Most of the particles are the size of sand grains, while a few are as big as marbles and even fewer are considerably larger. Although meteors rarely make it to the ground, they are known as meteorites when they do.

## ∧ PERSEID SHOWER 2009

This time-lapse image features a burst of Perseid meteors. The year 2009 was an "outburst" year—meaning that it featured more meteors than usual. Seven years later, in 2016, forecasters correctly predicted another Perseid outburst with double the typical number of shooting stars. Rates came close to two hundred meteors appearing in the sky per hour. Usually, Earth barely grazes the debris stream of Comet Swift-Tuttle; but occasionally, when Jupiter's gravity brings the stream a little closer, Earth moves through the middle, where the debris is much denser. By the time the debris enters Earth's atmosphere, becoming meteors, it has already traversed space for billions of miles.

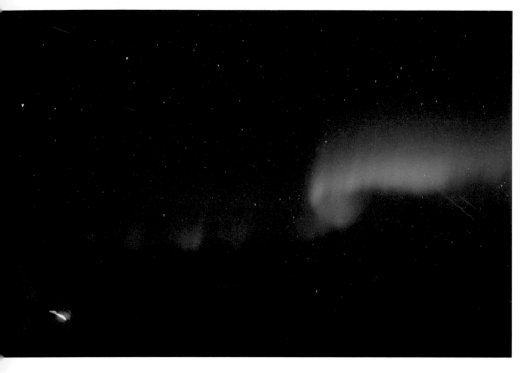

## < QUADRANTID METEOR SHOWER AND AN AURORA

This composite image was captured in 2008 by the Multi-Instrument Aircraft Campaign (MAC), which was part of a project studying the origin of meteor showers. The phenomena shown in this image are from the Quadrantid shower, whose meteors are faint compared to Geminid and Perseid meteors; however, the Quadrantid meteors can also feature enormous glowing tails that streak across the sky. The MAC aircraft captured images of more than one hundred meteors per hour during its observations. The tail of the airplane reflects a red beacon in the left of the image, and a bright green aurora pulses to the right.

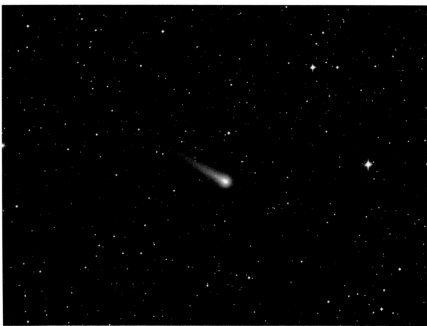

## < COMET ISON ON ITS WAY TO THE SUN

At the Marshall Flight Center in Huntsville, Alabama, a 14-inch telescope captured Comet ISON in a three-minute exposure. The telescope tracked the comet all the way to its perihelion, or closest approach to the Sun. In this image, the comet was 44 million miles (70.8 million kilometers) away from the Sun and 97 million miles (156 million kilometers) away from Earth. It was traveling at 136,700 miles (220,000 kilometers) per hour. While many comets that fly close to the Sun get suffused with enough solar heat to become bright spectacles in the night sky, this was not ISON's fate. On the day of its perihelion, it fell apart. Right before its demise, ISON's tail was 20 times wider than the full Moon, with a bright head visible to the naked eye right before dawn.

## THE MILKY WAY OVER EARTH

Expedition 41 crew member Reid Wiseman captured this stunning image off the coast of Africa while aboard the ISS. A star-studded night sky and the Milky Way loom over Earth, which appears to glow orange—courtesy of the sprawling Sahara sands below. The Sahara (which is Arabic for "Great Desert") covers 3.6 million square miles (9.4 million square kilometers) and is the largest hot desert on the planet—rivaled in size only by the cold deserts of the Arctic and Antarctica.

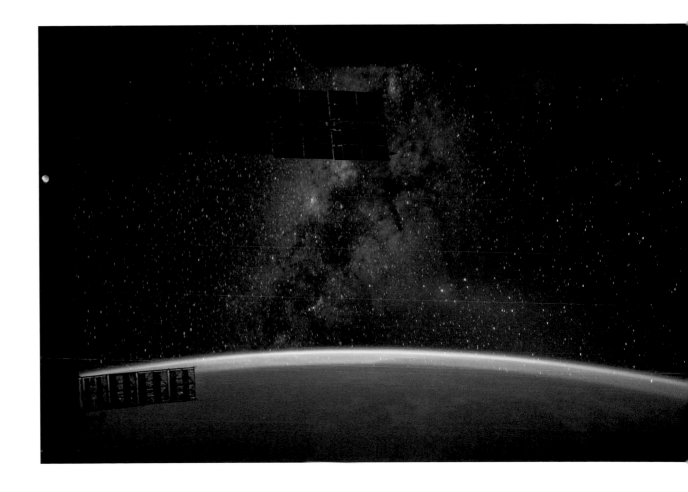

## ICEBERG IN NORTH STAR BAY

This spectacular image of a night sky above an iceberg in North Star Bay, Greenland, was captured on March 21, 2015, at 2:30 a.m. by scientist Jeremy Harbeck. During this time of year, the Sun does not set fully in the Arctic circle, so faint sunlight appears low on the horizon on the left side of the image. Thule Air Base is visible on the right. The Milky Way and a few barely perceptible meteors festoon the sky. Although the iceberg looks small, it is roughly the size of a large apartment building.

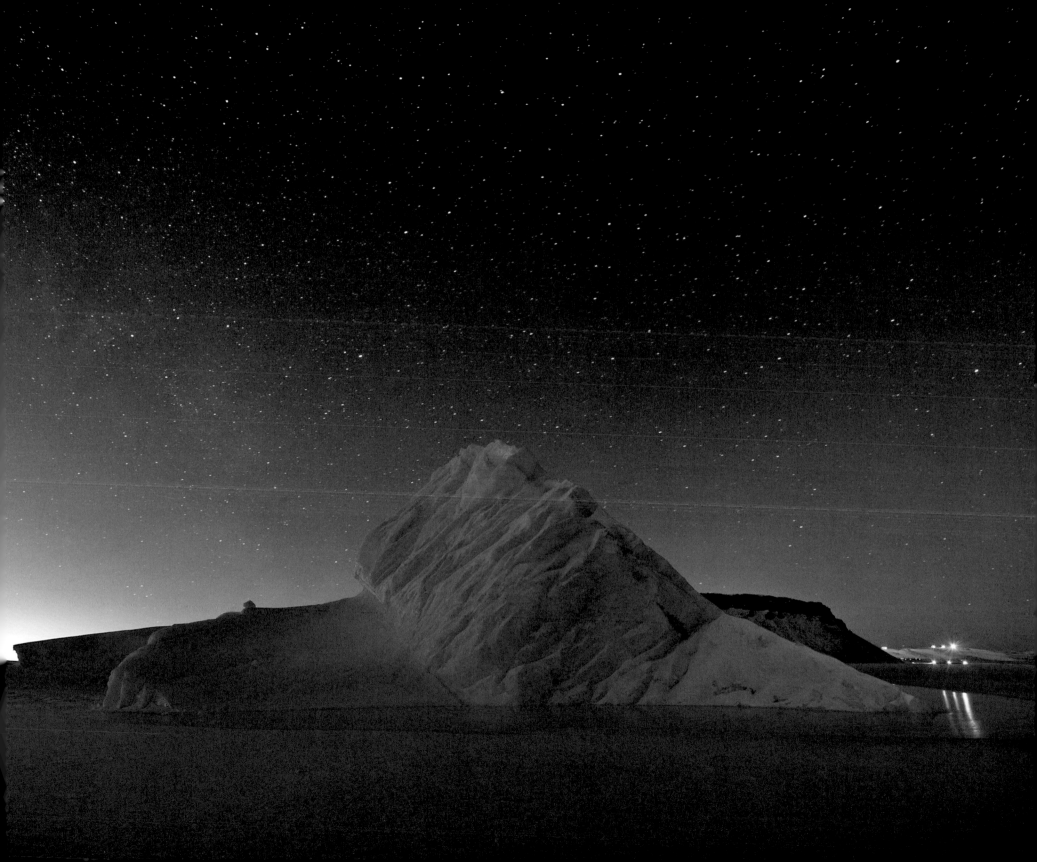

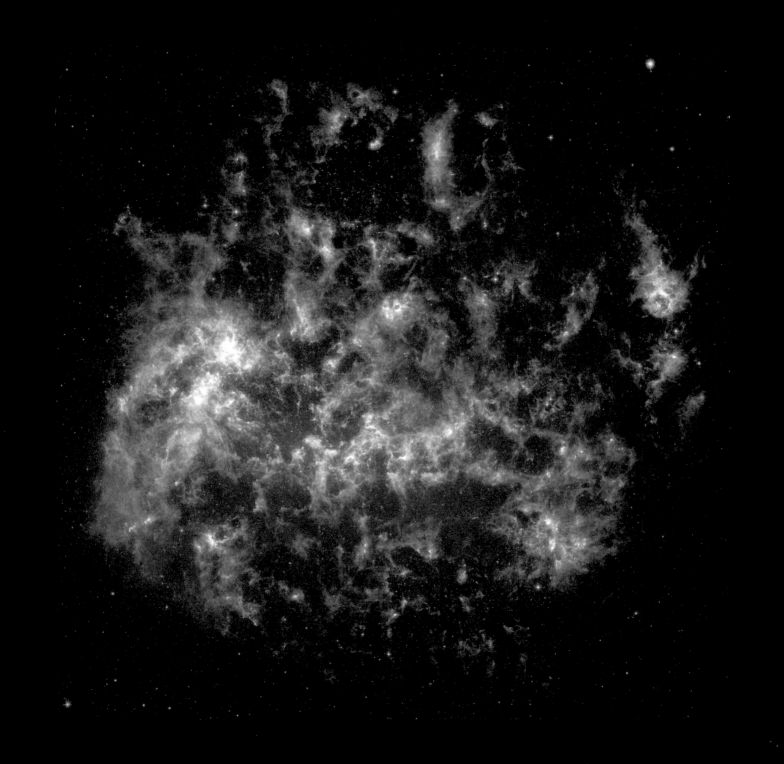

# LARGE MAGELLANIC CLOUD

The Large Magellanic Cloud, a dwarf galaxy that orbits our own, is located 160,000 light-years from Earth. Despite its diminutive size (a third of the width of the Milky Way), it is home to massive star-forming regions, from the Tarantula Nebula to the 30 Doradus Nebula— perhaps the most luminous star-making region in our vicinity, boasting numerous lagoons of gas, ultraviolet radiation, and eruptive activity. The Large Magellanic Cloud is also one of only three galaxies visible to the naked eye. This infrared composite from the Spitzer Space Telescope, composed of hundreds of thousands of individual images, shows roughly a third of the entire galaxy and offers a generous glimpse of the epic life cycles of stars, dust, and cosmic offal. The luminous band of blue across the middle features starlight from older stars, while the bright areas of color beyond it show new stars blanketed in dust. The red dots strewn throughout the image are distant galaxies. The reddish clouds correspond to dust heated by the stars, while areas of green harbor cooler interstellar gas and dust grains. This image not only uncovered roughly a million previously unknown objects, but also helps scientists better understand how molecular grains of dust contribute to the creation of new stars and galaxies.

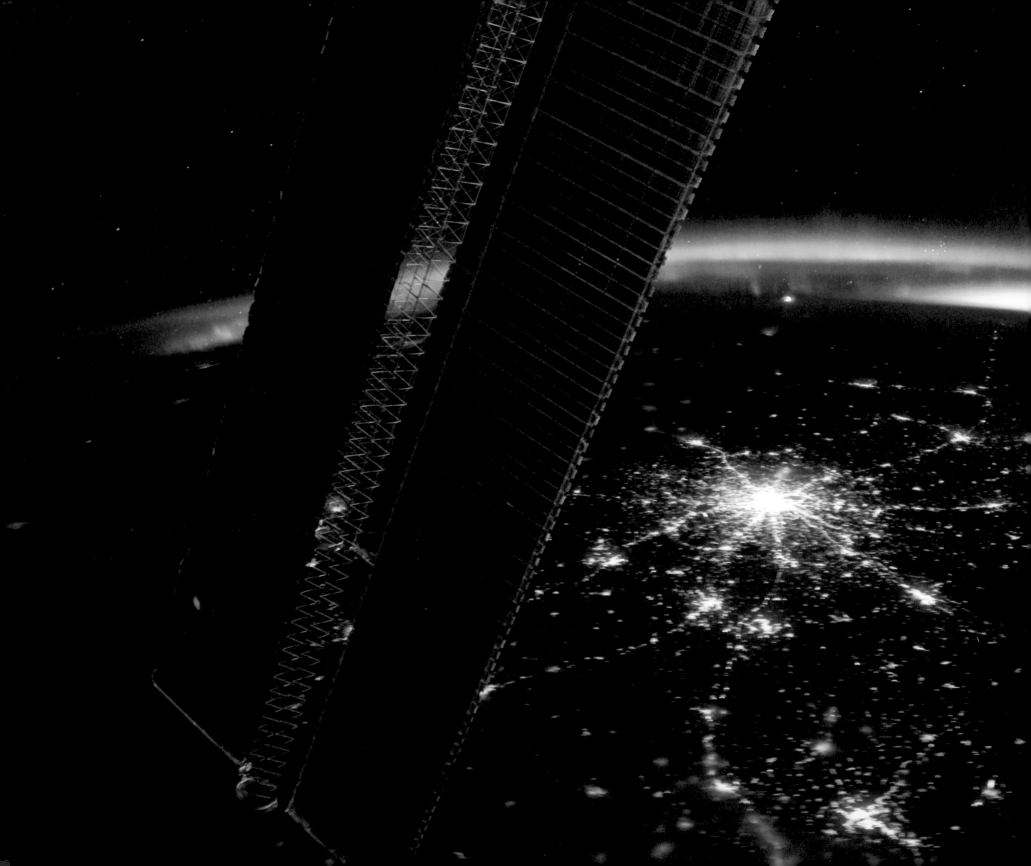

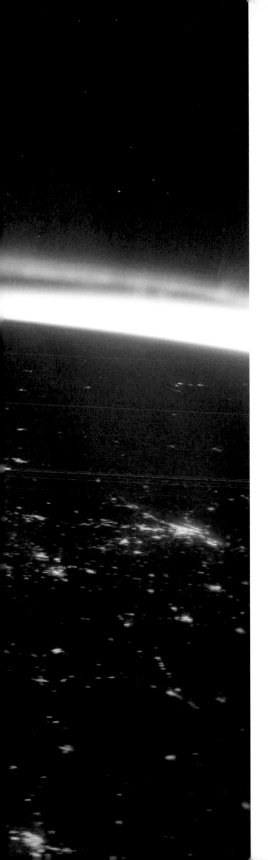

## AURORA BOREALIS OVER MOSCOW

This stunning nighttime image of Moscow was captured by the Expedition 30 crew from the ISS. On the left side of the image, the solar array panel of the ISS is visible, while daylight approaches from the right side of the image. The bright green halo is the aurora borealis. The aurora's appearance depends on a myriad of factors, from weather to solar activity to geographic location, but it typically appears between nine p.m. and midnight from late September to late March.

## ANDROMEDA IN INFRARED

NASA's Wide-Field Infrared Survey Explorer captured this image of the Andromeda Galaxy in infrared. Avenues of hot dust inhabit the spiral arms. It's believed that in roughly 3.75 billion years, Andromeda, which is approaching us at 68 miles (100 kilometers) per second, will collide with the Milky Way and form a massive elliptical galaxy. But some astronomers believe that Andromeda is already the result of two smaller galaxies colliding between 5 and 9 billion years ago.

## SUPERMOON

This image, taken on January 31, 2018, captures a rare super blue blood moon over the Trona Pinnacles in California's Desert National Conservation Area. The location of the image is as notable as the Moon itself: the massive calcium carbonate rocks on the site were most likely formed underwater 10,000 to 100,000 years ago.

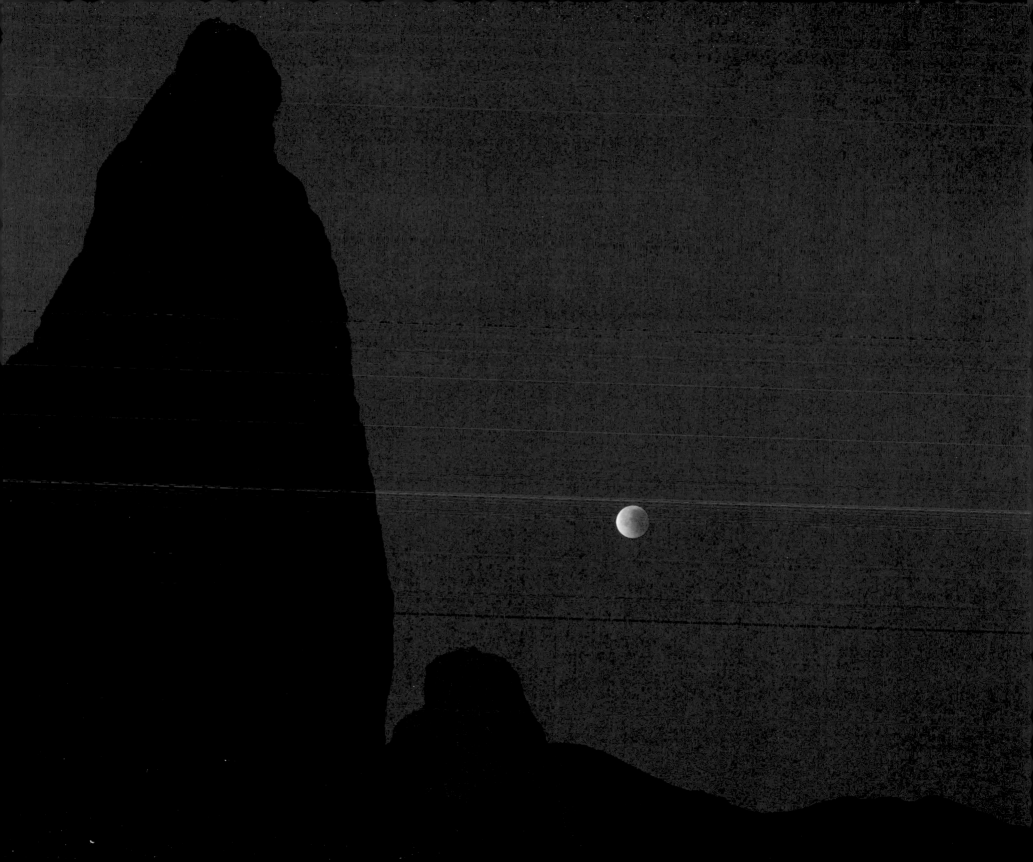

## TOTAL LUNAR ECLIPSE

April 15, 2014, marked the first total lunar eclipse of the year, which was visible across the United States in areas where weather conditions were optimal. During the eclipse, the Moon's appearance ranged from blood red to dark brown. This photo was captured in San Jose, California. In it, the Moon is in the shadow, or umbra, of Earth and therefore appears red. Earth's umbra is red at the edges because the planet's atmosphere scatters sunlight and filters out the other colors in the spectrum of visible light. The Sun, Earth, and Moon only line up about twice a year for lunar eclipses.

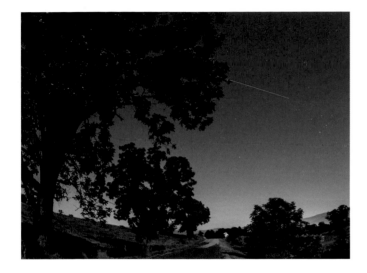

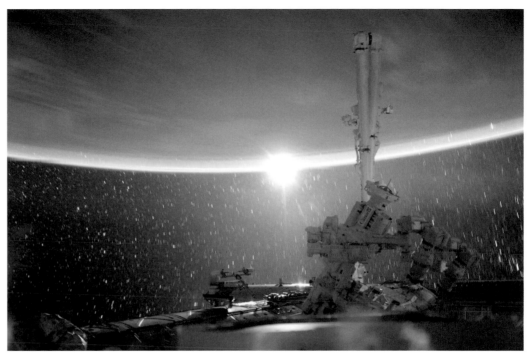

## ∧ ISS FLYING OVER EARTH

In this 30-second exposure captured over Elkton, Virginia, the ISS drifts across the sky. The ISS, which is typically 248 miles (400 kilometers) above Earth, is often visible from the ground and resembles an airplane—but with no flashing lights or changes of direction—or a radiant moving star. The station travels at 17,500 miles (28,000 kilometers) per hour, compared to the typical airplane flight speed of 600 miles (965 kilometers) per hour. You can track the ISS via an interactive map on the Spot the Station website. Because it completes several orbits a day and traverses areas where more than 90 percent of the planet's population lives, it's likely that you've spotted it once or twice.

## ∧ THE RISING MOON

Astronaut Scott Kelly captured this gorgeous image of the Moon rising above Earth's limb (the edge of Earth's atmosphere). When viewed from its side, Earth appears like a flattened disk, and its atmosphere resembles a luminous, colorful halo. Kelly spent almost a year on the ISS and 520 days in space. During his most recent mission, his work focused on developing our understanding of how the human body responds to long periods of time in space.

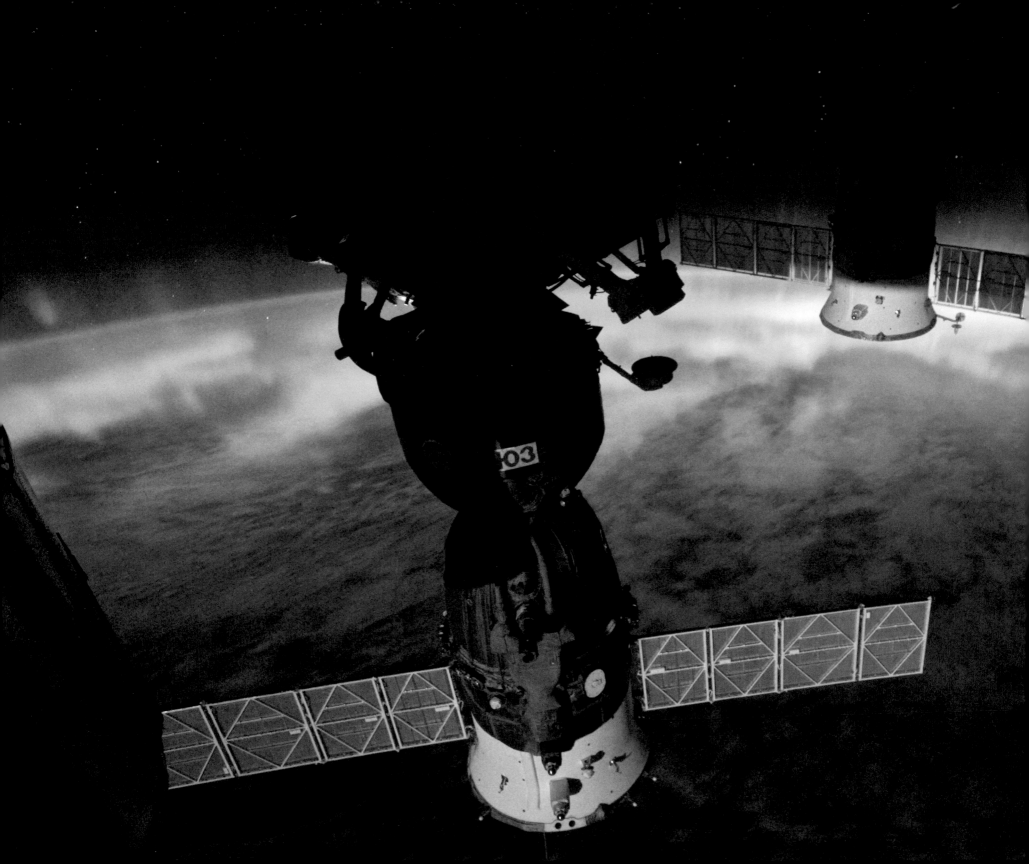

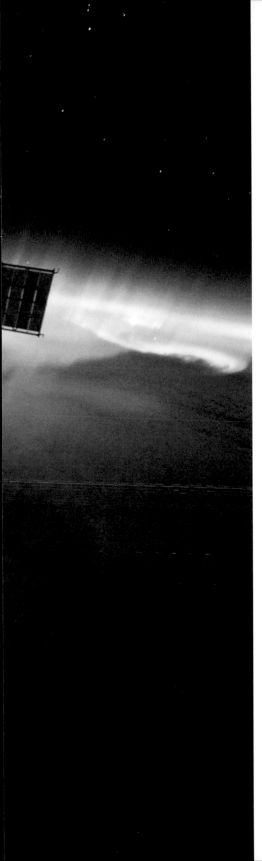

## AURORA AUSTRALIS

This image features the bright glow of the aurora australis (southern lights) near southern New Zealand. It was taken from one of the seven Earth-facing windows of the Cupola, an observatory module on the ISS. Auroras are natural displays of light that result when charged particles from the Sun's atmosphere crash into charged particles from Earth's atmosphere. The collisions occur at the North and South Poles and appear in an array of colors, from violet to green.

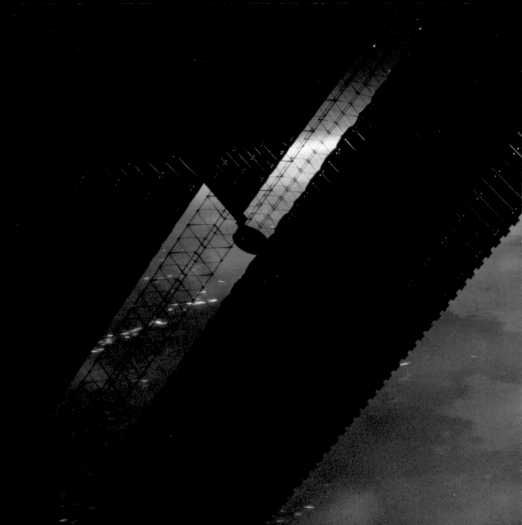

## AURORA BOREALIS OVER CANADA

The ISS was at its highest point above Earth when an Expedition 53 crew member captured this photograph of Canada. The ISS's solar arrays are visible on the left. Because the photograph was taken from a high vantage point, the area covered by the undulating aurora borealis appears much larger than it does in images snapped at different points in the ISS's orbit.

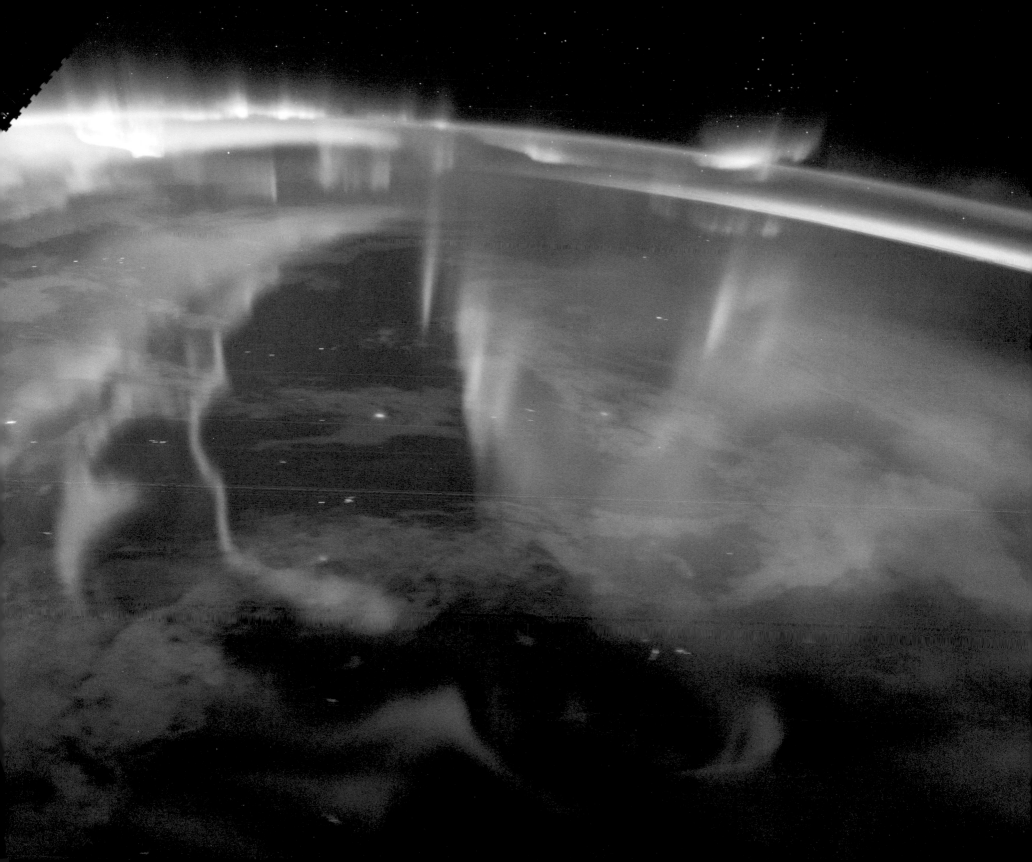

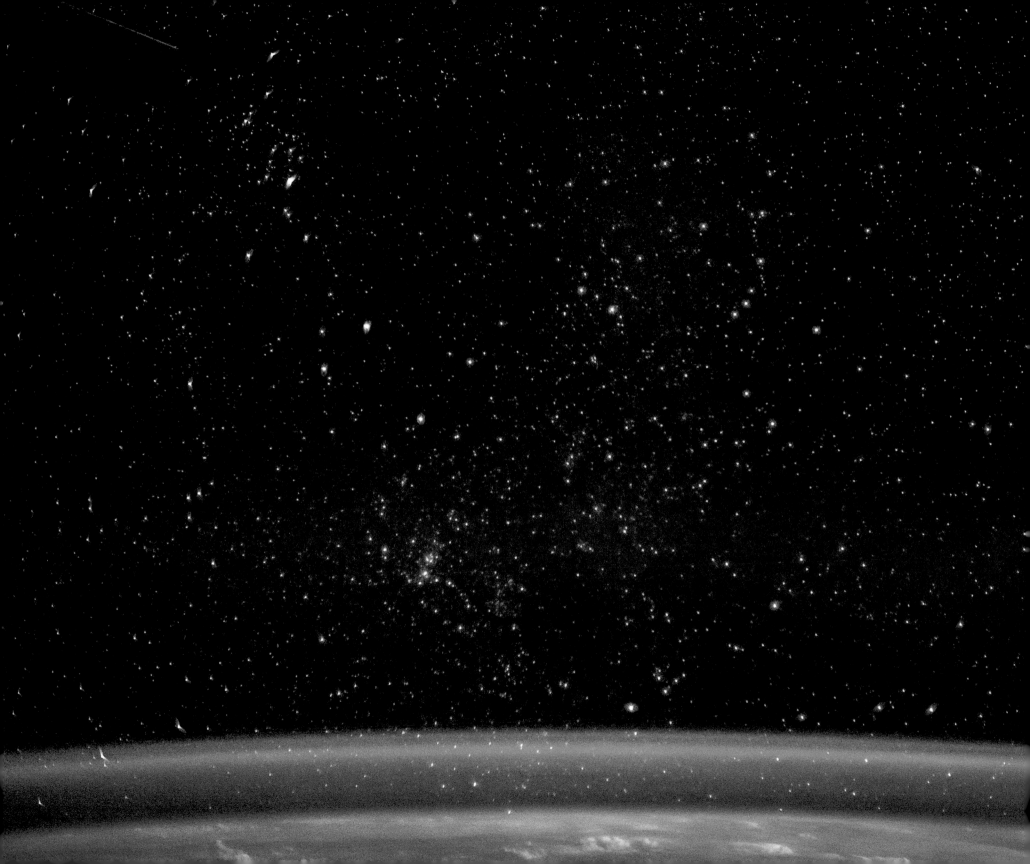

## GOLDEN AURORA

Astronaut Samantha Cristoforetti captured this image of a glowing golden aurora from the ISS, overlooking an area of Earth bordered by the United Kingdom, the Baltic area, and the Persian Gulf. You can distinguish between auroras and airglow because auroras form in a ring around the magnetic poles of the Earth, whereas airglow radiates across the entire sky and is always present. Auroras also appear in different colors at different times depending on the spectra of gases in Earth's atmosphere and the height at which the solar wind interacts with atoms and molecules in the atmosphere.

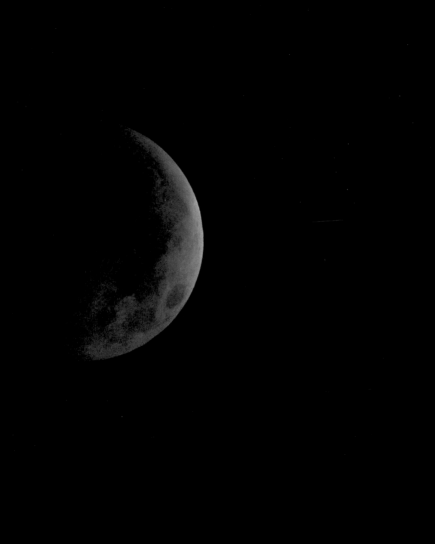

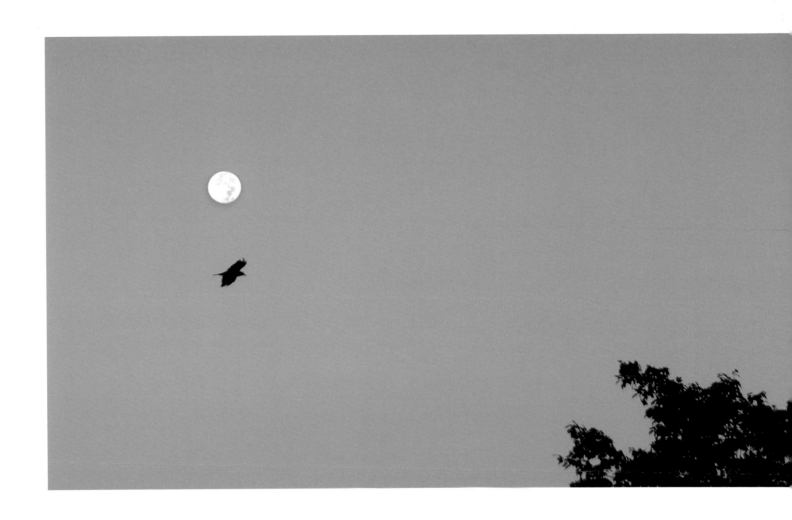

### < FULL MOON ON WINTER SOLSTICE

This photograph captures a rare event that occurred on December 21, 2010: a full moon coincided with the winter solstice and with a total lunar eclipse that lasted 3 hours and 28 minutes. Since 1793, a full moon has coincided with the winter solstice only 10 times, and the next time it happens will be in 2094. Although meteorologists view December 1 as the first real day of winter, astronomers and most other people view December 21 as the official start of the season. While meteorological seasons are based on the year's temperature cycle, astronomical seasons correspond to Earth's position relative to the Sun.

### ∧ HARVEST MOON

In some folklore, each full moon of the year has a particular name and connotation. The full moon that occurs close to the autumnal equinox is dubbed the harvest moon. Although the majority of harvest moons occur in September, every three years or so they fall toward the beginning of October.

## FULL MOON OVER TURIN

An Expedition 23 crew member on the ISS captured this luminous image of the French-Italian border, visible across the top center, below the Ligurian Sea. The metropolitan areas of Turin, Italy, and Lyon and Marseille, France, are visible here. The glint of the full moon is visible above the water of the Ligurian Sea. When the ISS orbits Earth, it often captures photographs that include sun glint, or the image of sunlight bouncing off water. Here, the moon glint creates an ethereal effect.

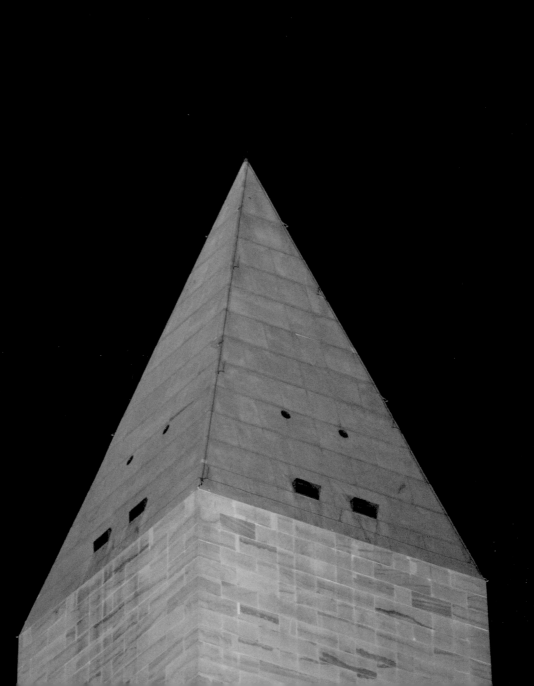

## < SUPERMOON BEHIND THE WASHINGTON MONUMENT

This perigee full moon, also known as a supermoon, was captured behind the Washington Monument on September 27, 2015. It coincided with a total lunar eclipse, a combination that will not occur again until 2033. During a lunar eclipse, the Moon crosses into Earth's shadow and reflects refracted sunlight, which makes it appear red in the sky. A supermoon occurs because the Moon's orbit is not a perfect circle, and there are times when the Moon comes closer to Earth. During its perigee, or closest approach, the Moon is 31,000 miles (49,890 kilometers) closer to our planet than when it is at its apogee (or farthest point). A perigee full moon appears 14 percent larger and 30 percent brighter in the sky than an apogee full moon. During this particular supermoon, the total eclipse lasted for an hour and 12 minutes and was visible across North and South America, Europe, Africa, and parts of West Asia and the Eastern Pacific.

## > SUPER BLOOD MOON

This stunning image of a blood-red supermoon was captured on January 31, 2018. This Moon was unique for a number of reasons. It occurred when the Moon was nearest to Earth (an orbital stage known as the perigee) and 14 percent brighter than normal, which makes it a supermoon. It was also the second full moon of the month, which is known as a blue moon. On top of that, the Moon passed through Earth's shadow, resulting in a complete lunar eclipse and causing it to appear red, so it was also a blood moon.

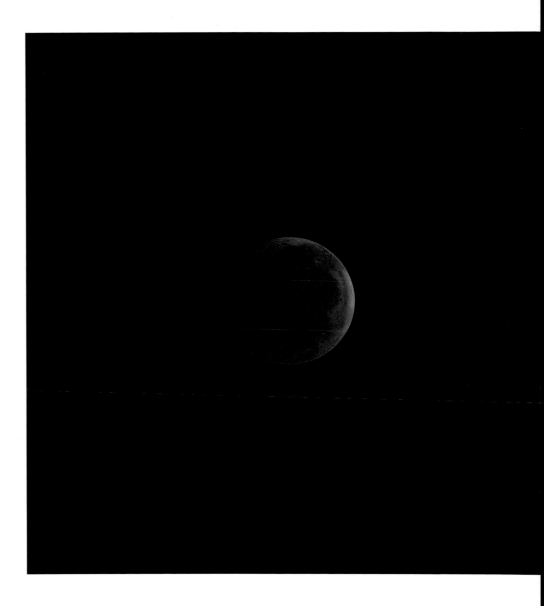

## FULL MOON

This composite image was developed from measurements by the Lunar Orbiter Laser Altimeter (LOLA), aboard the Lunar Reconnaissance Orbiter (LRO). Although the Moon always keeps the same face toward Earth, the tilt of its orbit offers us a series of different angles over the month. The 29.5-day lunar "cycle" begins with a new moon, which waxes (or grows) into a full moon and then gradually wanes until the cycle begins all over again. LOLA is responsible for more than 10 times as many elevation measurements than the sum total from all previous missions to the Moon. The view of the Moon in this image is based on the way it looks from the Northern Hemisphere. For a Southern Hemisphere view, it would be rotated 180 degrees.

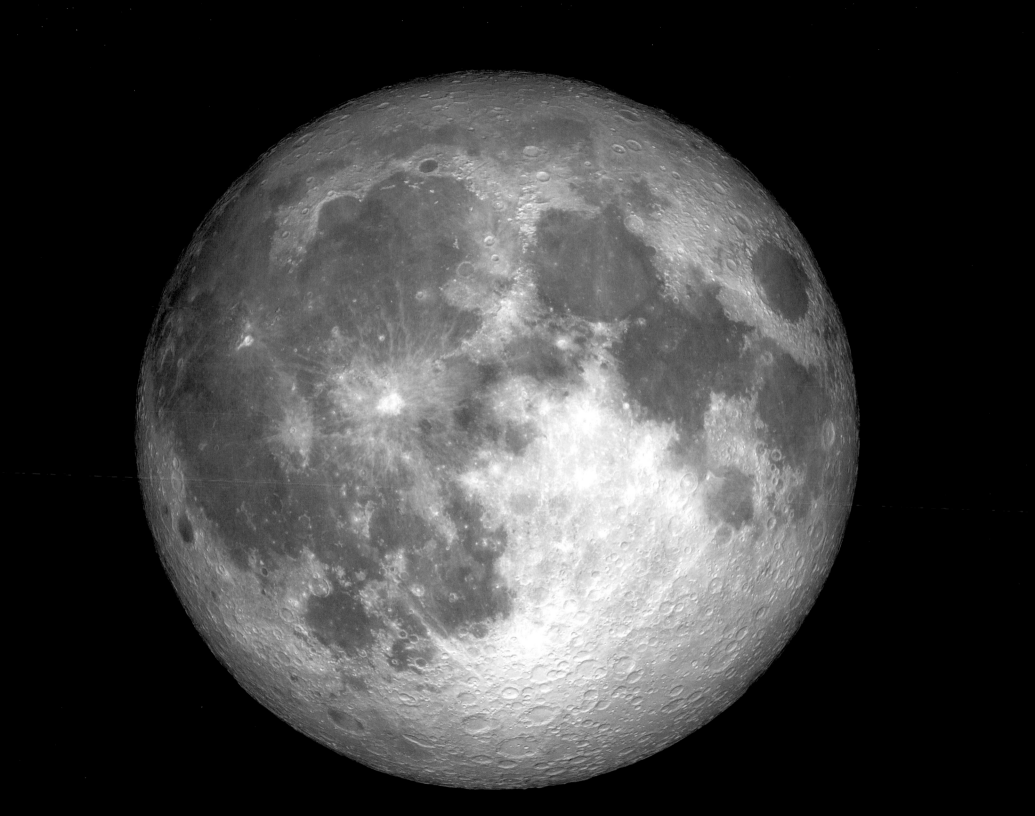

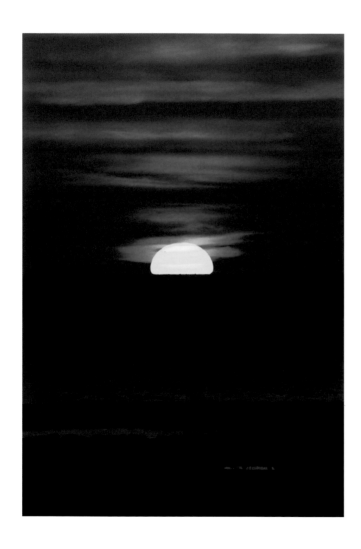

< **RADIANT SUNSET**

This brilliant sunset was captured on October 13, 2010, over NASA's Kennedy Space Center. One of the little-known facts about the setting Sun is that by the time we actually see it sinking below the horizon, it's already gone. This optical illusion is the result of how the atmosphere bends light. The scattered effect of light during a sunset occurs because our atmosphere acts like a prism. If Earth had no atmosphere, the Sun would simply look like it was dropping behind the horizon, with no additional effects.

> **TOTAL SOLAR ECLIPSE**

On August 21, 2017, a total solar eclipse swept across the contiguous United States. Here, the total eclipse is seen above Madras, Oregon. Total solar eclipses occur every three years on average and are visible in remote areas of Earth; it's much less frequent that they can be seen from coast to coast in North America. In fact, the last solar eclipse that was visible across the continent was on June 8, 1918. During the 2017 eclipse, the United States was the only country that experienced a total solar eclipse. Fourteen states went dark for the full two minutes of totality, with Oregon being the first state to experience this rare event.

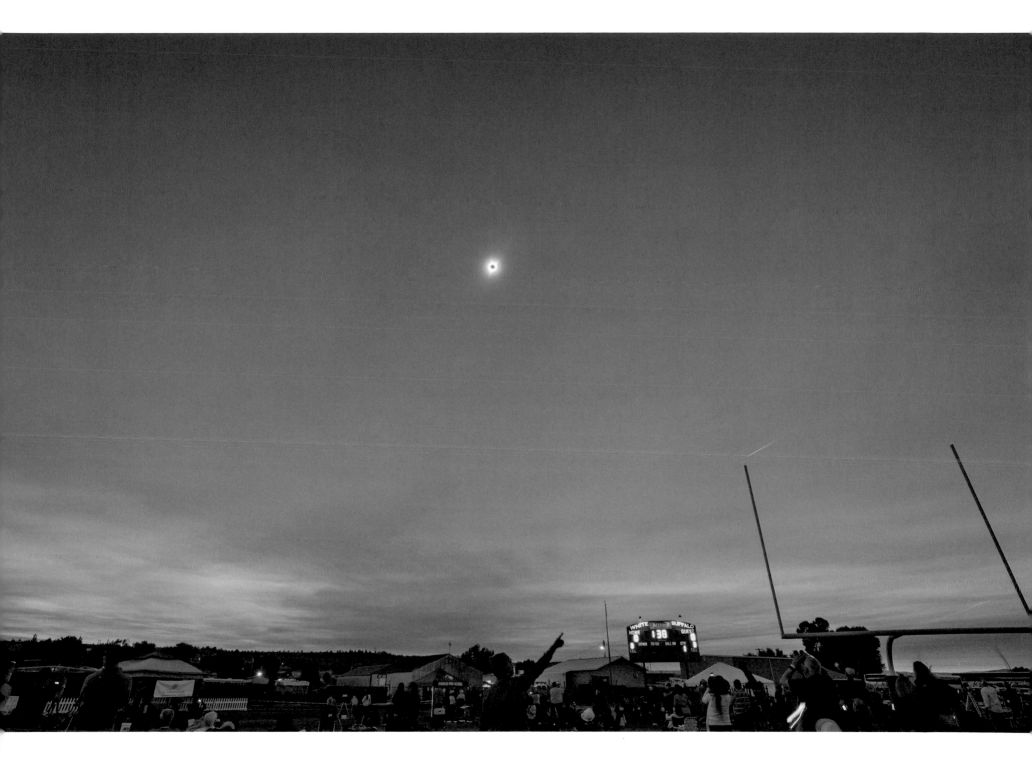

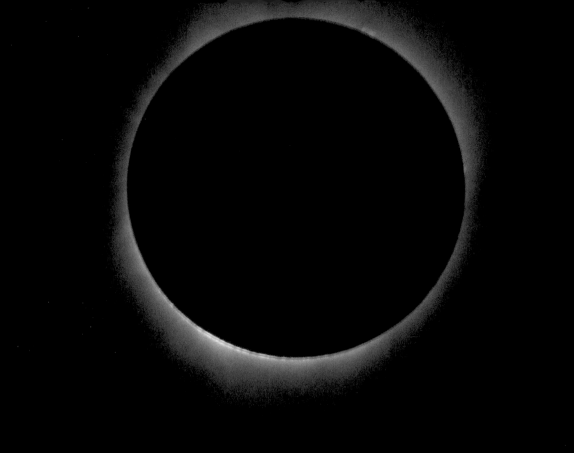

## BAILEY'S BEADS

This photo was captured during the total solar eclipse on August 21, 2017, which spanned the contiguous United States from the Pacific to the Atlantic coast. During the eclipse, the Sun's corona was visible as a series of spiked luminous flares. The red spots in the corona are known as Bailey's beads and occur when direct light from the sun shines through the rugged mountainous topography of the Moon. Light streams out from the Sun and into the valleys of the Moon, and is broken into bright red spots. Generally, these beads last for a few seconds, but they can remain for up to a minute.

## GLITTERING GALAXIES

In this image, two galaxies—M-81 or Bode's Galaxy (on the right) and M-82 or Cigar Galaxy (on the left)—appear side by side. The color image is the result of eighty-six 30-second exposures being stacked together, covering one square degree of the sky. Both galaxies are located in the constellation Ursa Major, 10 degrees northwest of the Big Dipper pointer star. The galaxies are about 150,000 light-years from one another. M-81 is a spiral galaxy about 12 million light-years from Earth, with an estimated mass of 50 billion solar masses (or 50 billion Suns). M-82 is a starburst galaxy, or a galaxy undergoing a high rate of new star formation. Its disk is distorted because of the gravitational effect of its larger neighbor, M-81.

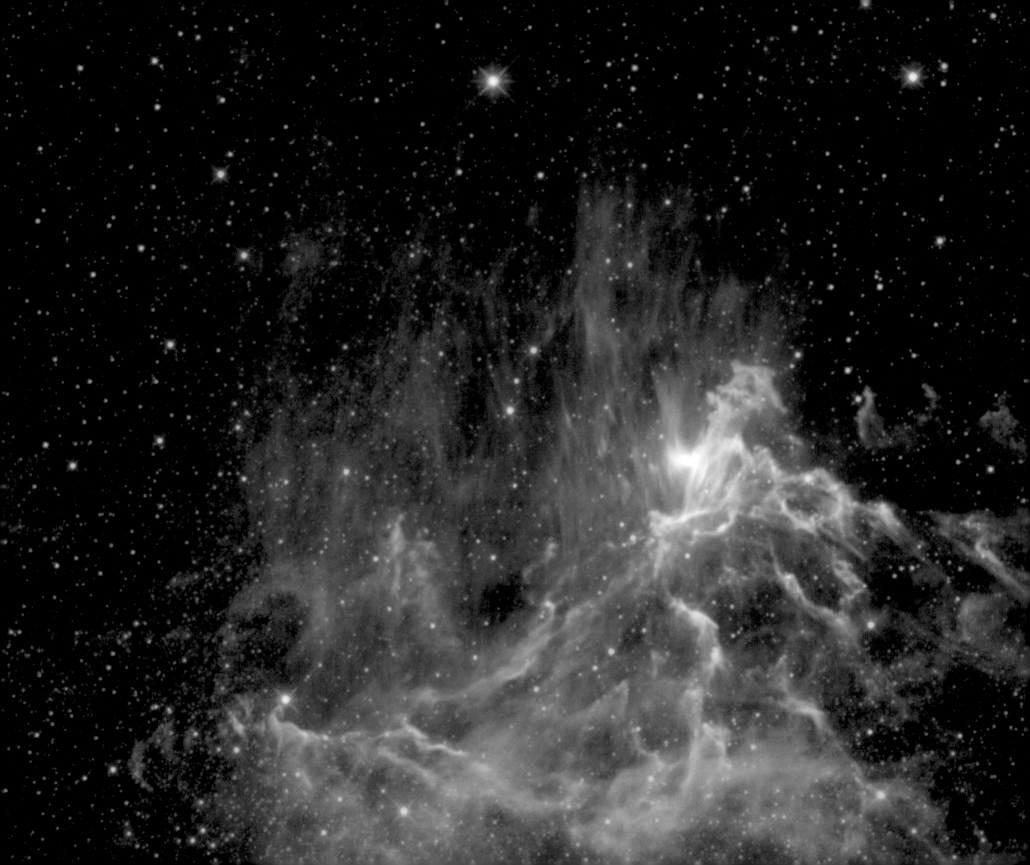

## FLAMING STAR NEBULA

NASA's Wide-Field Infrared Survey Explorer captured this image of the hot O-type star AE Aurigae, surrounded by the Flaming Star Nebula, which is about 5 light-years across and 1,500 light-years away. The nebula consists of both an emission nebula, which emits lights of various colors, and a reflection nebula, which reflects the light of AE Aurigae. AE Aurigae itself is a runaway star that was most likely dislodged after two binary star groups collided.

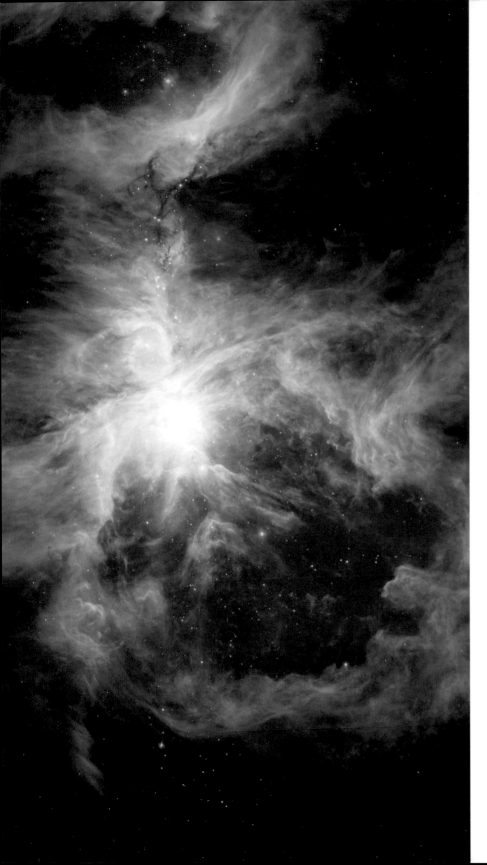

## < SWORD OF ORION

NASA's Spitzer Space Telescope captured the stellar nursery at the heart of the sword in the Orion constellation. The sword itself comprises three stars: Orionis, Theta Orionis, and Hatysa. The southernmost among them, Hatysa, is a luminous giant star that is a rare O-type, which means it is 15 to 90 times the mass of our Sun and has 40,000 to 1 million times its luminosity. However, it is central Theta Orionis that includes a complex of nebulae boasting thousands of young stars, including the spectacular area known as the Orion Nebula, seen in this image, which lies close to the middle of the sword.

## > UNICORN ROSE

The evocative Rosette Nebula is located in the constellation Monoceros, or the Unicorn. Monoceros is a cluster of faint stars whose closest areas are about 1,852 light-years from Earth. Aside from the stars that give it its distinctive name, Monoceros includes a triple star system, a pair of binary stars with a combined mass of more than 100 Suns, and the star-forming Cone Nebula. This image comes from NASA's Wide-Field Infrared Survey Explorer. The floral-shaped Rosette Nebula is also known as NGC 2237 and is a massive star-forming cloud that is about 4,500 to 5,000 light-years away from Earth.

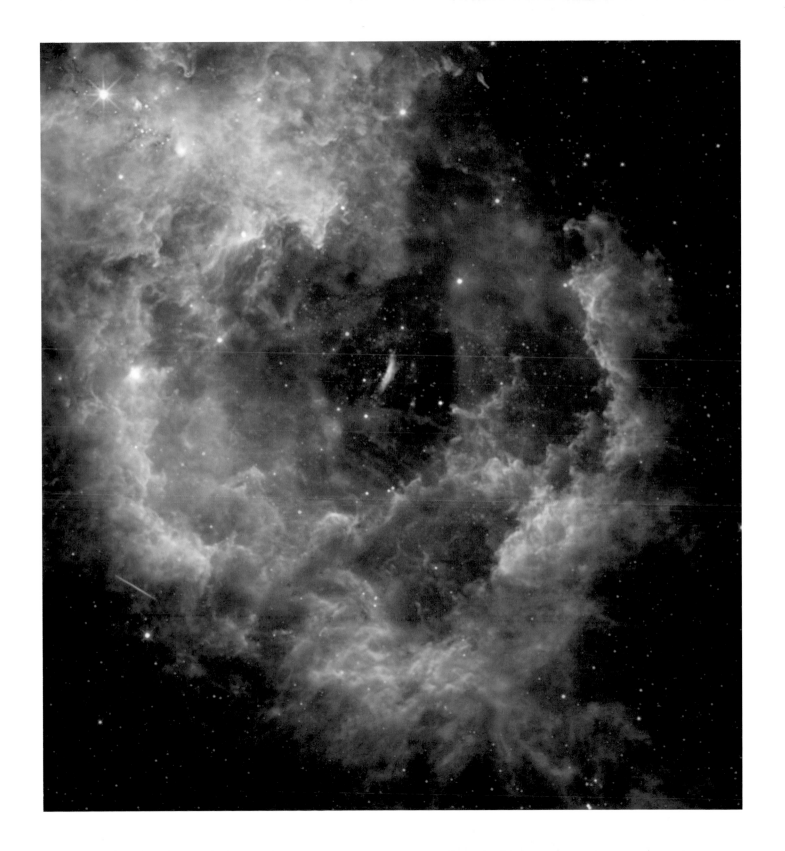

## CANOPUS, OR ALPHA CARINAE

Expedition 6 astronaut Donald R. Pettit took this photo while aboard the ISS. Canopus, or Alpha Carinae, is the second-brightest star in the night sky behind Sirius, and it lives 300 light-years from Earth in the constellation Carina. Alpha Carinae is a yellow-white super giant, 65 times the size of the Sun. In the Southern Hemisphere, Sirius and Canopus are visible and bright high in the firmament.

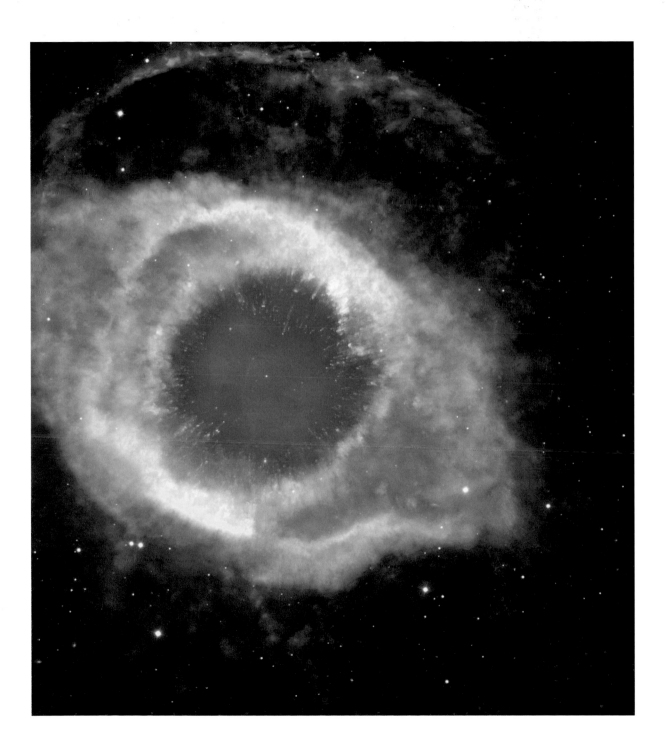

## HELIX NEBULA

This image of the Helix Nebula, which is 694.7 light-years away in the constellation Aquarius, is a composite from the Hubble and Spitzer space telescopes. The Helix Nebula is a planetary nebula, or the remnants of a star that was once a lot like our Sun. Such stars undergo huge nuclear fusion reactions in their cores, turning hydrogen into helium, before they die. The Helix Nebula is the closest bright nebula to our solar system and is also known as the Eye of God due to its distinctive appearance. However, when it comes to amateur stargazing, only large ground-based telescopes can capture its radial streaks, which are featured so prominently here.

# A DIAMOND AND LIZARD IN THE SKY

This image hails from the Hubble Space Telescope and captures a bright, irregular galaxy known as NGC 7250 (on the right of the image). Located in the Lacerta, or lizard, constellation, about 45 million light-years from Earth, the blue galaxy's star-formation rate is much higher than the Milky Way's. In 2013, scientists discovered a supernova in the galaxy roughly 2.4 hours after the explosion, which made it the earliest detected supernova at the time. However, in this image, the galaxy's radiance is second to the bright star on its left, known as TYC 3203-450-1, which is 1 million times closer to us than NGC 7250. TYC 3203-450-1 is what's known as a foreground star, a type of star that can hinder astronomers who want to study the more distant objects upstaged by its luminosity.

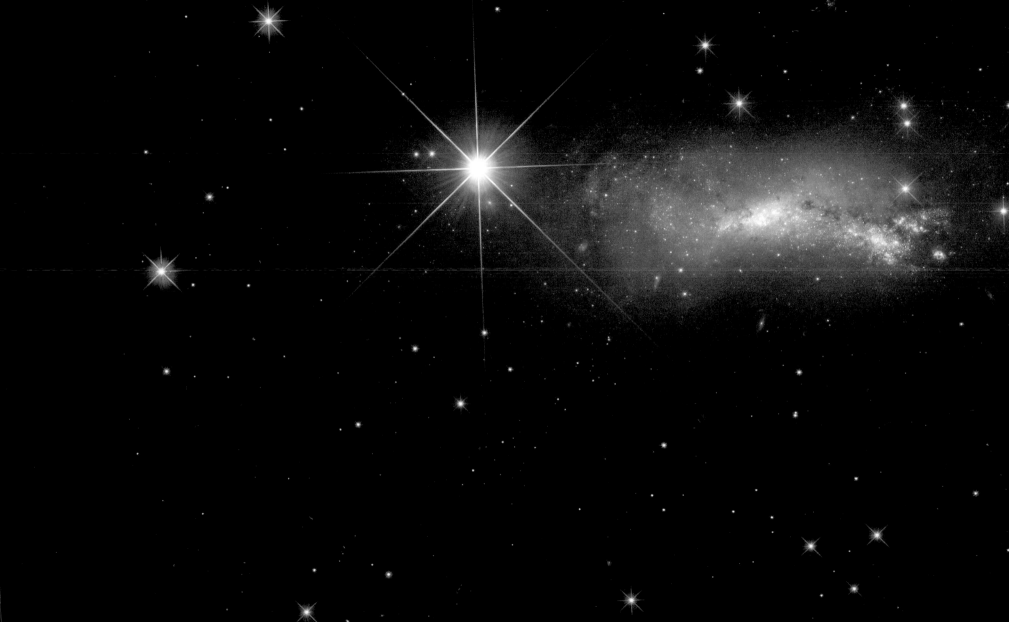

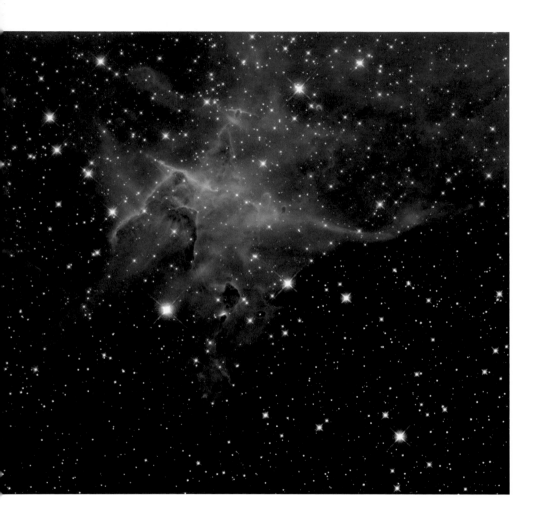

## < MYSTIC MOUNTAIN

The Hubble Space Telescope's Wide Field Camera 3 took this near-infrared-light image of a gaseous cradle of newborn stars in the Carina Nebula, which is 7,500 light-years away from us. The transparent effect is the result of infrared light from numerous background stars penetrating the gas and dust. Inside the nebula are several visible stars. The Carina Nebula was formed when ultraviolet radiation and stellar winds flowed from hot stars, creating dramatic towers of gas that gained them the name "Mystic Mountain." This area is also home to Herbig-Haro objects, which result from twin jets of gas released in opposite directions from a relatively young star.

## > SCORPION CLAW

This infrared view of the reflection nebula DG 129 was taken by NASA's Wide-Field Infrared Survey Explorer. DG 129 is in the constellation of Scorpius, 500 light-years away. It's often viewed as an arm and hand rising out of cosmic darkness. A reflection nebula is visible only because of light that shines upon it from a nearby source. The bright greenish star on the right is Pi Scorpii, which forms part of the scattering of celestial objects that mark one of the "claws" of the scorpion.

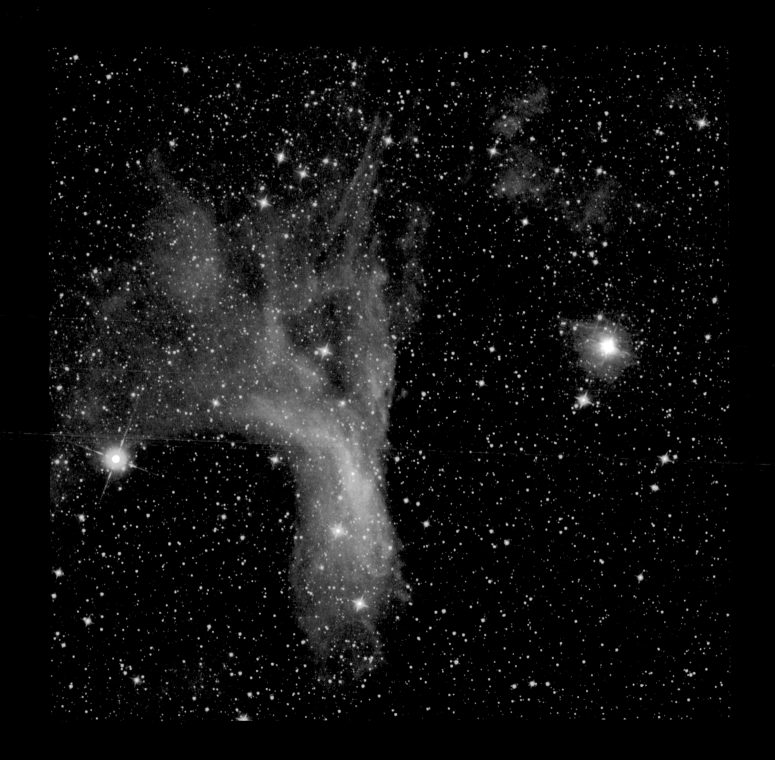

## NGC 1333

This bright composite image of the reflection nebula NGC 1333 hails from NASA's Chandra X-Ray Observatory and Spitzer Space Telescope. The pink regions were captured by Chandra, while the red regions show infrared data from Spitzer. Extra optical data for the image were captured by the Digitized Sky Survey and National Optical Astronomical Observatories outside Tucson, Arizona. Data from Chandra uncovered 95 new stars, 41 of which had not been detected before while using Spitzer data alone. Many reflection nebulae have a predominantly bluish hue, the result of light from a nearby star reflecting off the dust cloud. Typically, the size of dust grains in the nebula is comparable to blue light's wavelength, so blue light is scattered far more efficiently than longer wavelengths.

# CRAB NEBULA

This colorful image of the Crab Nebula includes data from five telescopes: the VLA (radio) in red; Spitzer Space Telescope (infrared) in yellow; Hubble Space Telescope (visible light) in green; XMM-Newton (ultraviolet) in blue; and Chandra X-Ray Observatory (X-ray) in purple. The Crab Nebula is one of the most famous supernovae to grace the night skies. It was first seen by Chinese astronomers in the year 1054, and its scattered remnants are still floating through the Milky Way today. Supernovae are stars that become extremely bright due to explosions that coincide with stellar death and propel most of the star's matter out into space. There are two types of supernovae. The first occurs in a binary star system in which a white dwarf siphons matter from its orbiting star (this is also known as a Type 1 supernova). When the white dwarf gets too massive, it explodes. The second type of supernova happens when a single star is at the end of its life cycle (known as a Type 2 supernova). Only an extremely massive star can go supernova (meaning it won't happen to our sun). When the star's nuclear fuel is depleted, its mass gradually gets sucked into the core. The core becomes heavy, to the point that its gravitational force makes the star collapse upon itself, resulting in a detonation of cosmic fireworks. The Crab Nebula's dust cloud is set in motion by the Crab Pulsar, a fast-moving neutron star (the extra-dense remnant of a star after it goes supernova) at the core of the nebula. The presence of the pulsar demonstrates that it formed during a Type 2 core-collapse supernova, as Type 1 supernovas don't generate pulsars.

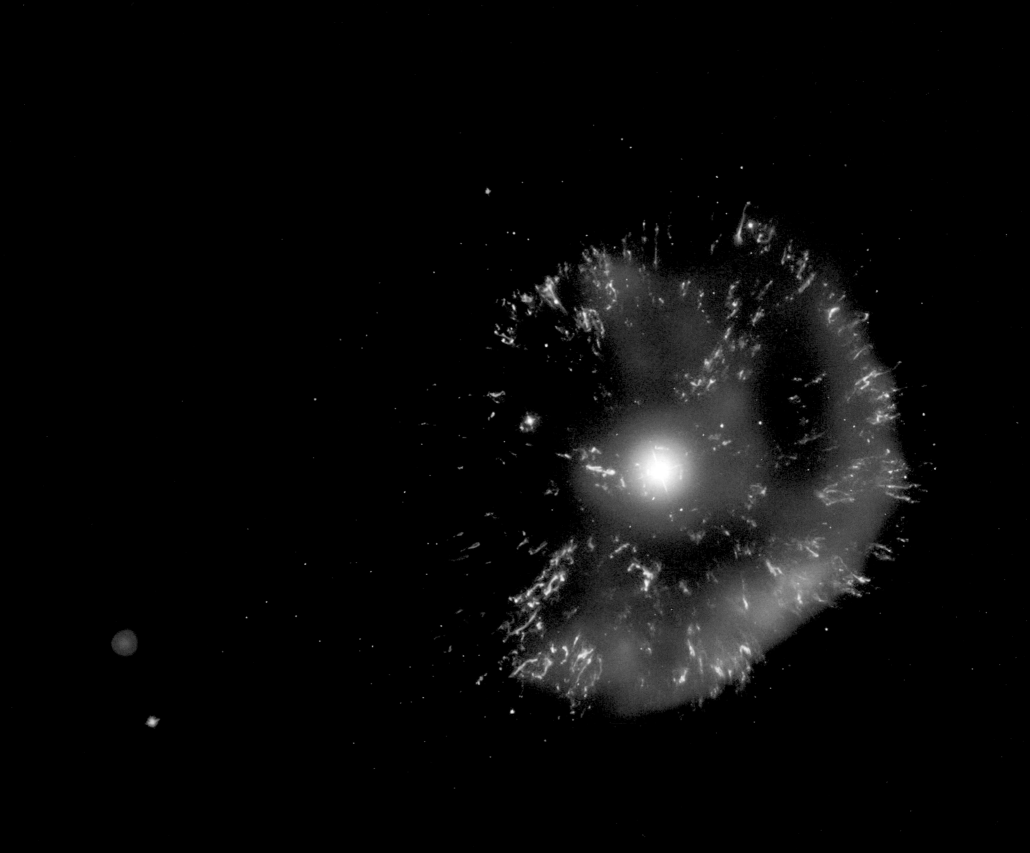

## GK PERSEI, AKA FIREWORK NOVA

The Chandra X-Ray Observatory tracked the classical nova GK Persei over a 13-year period, from 2000 to 2013. Back in 1901, it dominated the night sky as one of the brightest visible objects. A classical nova results when a thermonuclear explosion occurs on the surface of a white dwarf, which is what a Sun-like star gradually evolves into. It's a smaller-scale version of a supernova, which occurs when an enormous bright star explodes and often outshines other objects in the night sky. Classical novas are far more common than supernovas. Over the 13-year data span from Chandra, GK Persei's debris expanded at 700,000 miles (1,126,541 kilometers) per hour, meaning it moved approximately 90 billion miles (145 billion kilometers).

# BIBLIOGRAPHY

Dickinson, Terence. *NightWatch: A Practical Guide to Viewing the Universe*. Richmond Hill, ON: Firefly Books, 2016.

Kaliff, Will. *See It with a Small Telescope*. Berkeley, CA: Ulysses Press, 2017.

Nordgren, Tyler. *Sun Moon Earth: The History of Solar Eclipses from Omens of Doom to Einstein and Exoplanets*. New York: Basic Books, 2016.

Pederson, Daryl, and Calvin Hall. *The Northern Lights: Celestial Performances of the Aurora Borealis*. Seattle, WA: Sasquatch Books, 2015.

Starkey, Natalie. *Catching Stardust: Comets, Asteroids, and the Birth of the Solar System*. New York: Bloomsbury Sigma, 2018.

## WEB RESOURCES
NASA, www.nasa.gov
NASA Earth Observatory, www.earthobservatory.nasa.gov

# IMAGE CREDITS

Front cover: Golden Aurora
Credit: ESA/NASA/Samantha Cristoforetti
https://images.nasa.gov/details-iss042e037846.html

Back cover: Iceberg in North Star Bay
Credit: NASA Earth Observatory
https://www.flickr.com/photos/gsfc/17288702816/in/album
-72157670516867236/

Page 8: Perseid Shower 2016
Credit: NASA/Bill Ingalls
https://www.nasa.gov/image-feature/perseid-meteor-shower
-2016-from-west-virginia

Page 11: Bright Andromeda
Credit: NASA/MSFC/MEO/Bill Cooke
https://www.nasa.gov/topics/solarsystem/features/watchtheskies
/andromeda-galaxy.html

Pages 16–17: Stargazing from the ISS
Credit: NASA
https://www.nasa.gov/image-feature/stargazing-from-the-international
-space-station

Page 18: Omega Centauri
Credit: NASA/JPL-Caltech/UCLA
https://images.nasa.gov/details-PIA13125.html

Page 19: Sagittarius A*
Credit: NASA/ESA/G. Brammer
https://images.nasa.gov/details-GSFC_20171208_Archive_e001362.html

Page 21: A Burst Bubble
Credit: NASA/JPL-Caltech/E. Churchwell, University of
Wisconsin-Madison
https://images.nasa.gov/details-PIA07841.html

Page 22: Pacman Nebula
Credit: NASA/JPL-Caltech/UCLA
https://images.nasa.gov/details-PIA14873.html

Page 25: Skies over Kiruna
Credit: NASA/University of Houston/Michael Greer
https://images.nasa.gov/details-GSFC_20171208_Archive_e000229.html

Page 26: Oriole IV Launching into an Aurora
Credit: NASA/Jamie Adkins
https://images.nasa.gov/details-GSFC_20171208_Archive_e000809.html

Page 27: Geminid Meteor Shower
Credit: NASA/Marshall Space Flight Center
https://blogs.nasa.gov/Watch_the_Skies/2015/12/09/join-nasas-geminid
-meteor-shower-tweet-chat-on-december-13-14/

Pages 28–29: Airglow
Credit: NASA/ISS
https://www.nasa.gov/image-feature/earths-atmospheric-glow-and-the
-stars-of-the-milky-way

Pages 30–31: The Upper Atmosphere
Credit: ISS Crew Earth Observations Facility/NASA/JSC
https://eoimages.gsfc.nasa.gov/images/imagerecords/91000/91863/
iss054e005626_lrg.jpg

Page 33: Comet Lovejoy over the Southern Hemisphere
Credit: NASA/ISS/Dan Burbank
https://images.nasa.gov/details-iss030e015472.html

Page 34: Comet Lovejoy
Image credit: NASA/MSFC/Jacobs Technology/ESSSA/Aaron Kingery
https://www.nasa.gov/topics/solarsystem/features/watchtheskies/comet
-lovejoy-ursa-major.html

Page 35: Comet Lovejoy from the ISS
NASA/ISS
https://images.nasa.gov/details-iss030e017838.html

Page 36: Comet Lovejoy from 40 Million Miles Away
Credit: NASA/Marshall Space Flight Center/Meteoroid Environment
Office/Aaron Kingery
https://www.nasa.gov/topics/solarsystem/features/watchtheskies/comet
-lovejoy-big-dipper.html

Pages 38–39: Comet PanSTARRS
Credit: NASA/MSFC
https://www.nasa.gov/sites/default/files/images/734065main_panst_full.jpg

Pages 40–41: Comet Lovejoy over Chile
Credit: NASA/ISS
https://spaceflight.nasa.gov/gallery/images/station/crew-30/hires
/iss030e020039.jpg

Page 43: Cygnus Burning in Earth's Atmosphere
Credit: NASA
https://www.nasa.gov/content/cygnus-re-enters-atmosphere

Pages 44–45: Expedition Soyuz Meets a Meteor
Credit: NASA/Joel Kowsky
https://www.nasa.gov/image-feature/expedition-46-soyuz-rollout

Page 47: Space Shuttle Endeavour Liftoff from a Distance
Credit: NASA/Johnson Space Center
https://images.nasa.gov/details-STS113-S-007.html

Page 48: Space Shuttle Endeavour Liftoff up Close
Credit: NASA/JSC
https://images.nasa.gov/details-sts113-s-037.html

Page 49: CONTOUR
Credit: NASA/KSC
https://images.nasa.gov/details-KSC-02pp1124.html

Page 51: Night Flight
Credit: NASA
https://www.nasa.gov/multimedia/imagegallery/image_feature_2049.html

Page 52: Trails of Jet Streams
Credit: NASA/James Mason-Foley
https://svs.gsfc.nasa.gov/10922

Page 53: Rockets Flying through Active Auroras
Credit: NASA/Terry Zaperach
https://images.nasa.gov/details-GSFC_20171208_Archive_e000127.html

Pages 54–55: Antares Rocket and a Full Moon
Credit: NASA/Aubrey Gemignani
https://images.nasa.gov/details-201407120011HQ.html

Page 56: Space Shuttle Atlantis
Credit: NASA/Troy Cryder
https://images.nasa.gov/details-KSC-2009-6301.html

Page 57: Space Shuttle *Columbia*
Credit: NASA/Kennedy Space Center
https://images.nasa.gov/details-KSC-99pp0958.html

Page 58: A Diamond Ring
Credit: NASA/Carla Thomas
https://www.nasa.gov/centers/armstrong/multimedia/imagegallery/2017
_total_solar_eclipse/AFRC2017-0233-009.html

Page 60: Noctilucent Clouds 2016
Credit: ESA/NASA
https://www.nasa.gov/image-feature/space-station-view-of-noctilucent-clouds

Page 61: Noctilucent Clouds 2012
Credit: NASA
https://www.nasa.gov/multimedia/imagegallery/image_feature_2292.html

Page 62: Zeta Ophiuchi
Credit: NASA/JPL-Caltech/UCLA
https://images.nasa.gov/details-PIA13455.html

Page 64: Bright Aurora
Credit: ESA/NASA
https://www.nasa.gov/image-feature/space-station-view-of-auroras

Page 65: Star Disk
Credit: NASA/ESA/Hubble Heritage (STScI/AURA) ESA/Hubble Collaboration; Acknowledgment: M. Crockett and S. Kaviraj (Oxford University, UK), R. O'Connell (University of Virginia), B. Whitmore (STScI) and the WFC3 Scientific Oversight Committee
https://images.nasa.gov/details-GSFC_20171208_Archive_e001956.html

Page 67: Nova Centauri
Credit: NASA/MSFC/ESSSA/Aaron Kingery
https://www.nasa.gov/watchtheskies/new-nova-star-australia.html

Page 68: Milky Way from the Spitzer
Credit: NASA/JPL-Caltech/University of Wisconsin
https://images.nasa.gov/details-PIA05989.html

Page 69: Cepheus B
Credit: NASA/Chandra X-ray Center/JPL-Caltech/Pennsylvania State University/Harvard-Smithsonian Center for Astrophysics
https://images.nasa.gov/details-PIA12169.html

Page 70: Perseid Shower 2015
Credit: NASA/Bill Ingalls
https://www.nasa.gov/image-feature/perseid-meteor-shower

Page 71: Perseid Shower 2009
Credit: NASA/JPL
https://www.flickr.com/photos/nasamarshall/28459570870/in/album
-72157665270545133/

Page 72: Quadrantid Meteor Shower and an Aurora
Credit: NASA/Caltech/Jeremie Vaubaillon et al.
https://www.nasa.gov/multimedia/imagegallery/image_feature_991.html

Page 72: Comet ISON on Its Way to the Sun
Image credit: NASA/MSFC/Aaron Kingery
https://images.nasa.gov/details-GSFC_20171208_Archive_e001322.html

Page 73: The Milky Way over Earth
Credit: NASA/ISS
https://www.nasa.gov/image-feature/panorama-of-the-night-sky
-and-the-milky-way

Page 75: Iceberg in North Star Bay
Credit: NASA Earth Observatory
https://www.flickr.com/photos/gsfc/17288702816/in/album
-72157670516867236/

Page 76: Large Magellanic Cloud
Image Credit: NASA/JPL-Caltech/STScI
http://photojournal.jpl.nasa.gov/catalog/PIA07137

Page 78–79: Aurora Borealis over Moscow
Credit: NASA
https://www.nasa.gov/multimedia/imagegallery/image_feature_2221.html

Pages 80–81: Andromeda in Infrared
Credit: NASA/JPL-Caltech/UCLA
https://images.nasa.gov/details-PIA12834.html

Pages 82–83: Supermoon
Credit: NASA/Lauren Hughes
https://images.nasa.gov/details-AFRC2018-0020-07.html

Page 84: Total Lunar Eclipse
Credit: NASA Ames Research Center/Brian Day
https://www.nasa.gov/content/total-lunar-eclipse-0

Page 85: ISS Flying over Earth
Credit: NASA/Bill Ingalls
https://spotthestation.nasa.gov/message_example.cfm#ExamplePhoto

Page 85: The Rising Moon
Credit: NASA/ISS/Scott Kelly
https://www.nasa.gov/image-feature/moonrise-is-upon-us

Pages 86–87: Aurora Australis
Credit: NASA/International Space Station
https://www.nasa.gov/mission_pages/station/multimedia/gallery/iss029e008433.html

Page 88–89: Aurora Borealis over Canada
Credit: NASA
https://www.nasa.gov/image-feature/northern-lights-over-canada-0

Pages 90–91: Golden Aurora
Credit: ESA/NASA/Samantha Cristoforetti
https://images.nasa.gov/details-iss042e037846.html

Page 92: Full Moon on Winter Solstice
Credit: NASA/Bill Ingalls
https://images.nasa.gov/details-201012210003HQ.html

Page 93: Harvest Moon
Credit: NASA/Goddard Space Flight Center/Debbie McCallum
https://images.nasa.gov/details-GSFC_20171208_Archive_e001379.html

Pages 94–95: Full Moon over Turin
Credit: NASA
https://images.nasa.gov/details-GSFC_20171208_Archive_e001240.html

Page 96: Supermoon behind the Washington Monument
Credit: NASA/Aubrey Gemignani
https://www.nasa.gov/image-feature/supermoon-eclipse-in-washington

Page 97: Super Blood Moon
Credit: NASA
http://www.armaghplanet.com/blog/the-february-night-sky-2018.html

Page 99: Full Moon
Credit: NASA/GSFC
https://images.nasa.gov/details-GSFC_20171208_Archive_e001861.html

Page 100: Radiant Sunset
Credit: NASA/Dimitri Gerondidakis
https://climate.nasa.gov/climate_resources/87/vivid-sunset/

Page 101: Total Solar Eclipse
Credit: NASA/Aubrey Gemignani
https://www.nasa.gov/image-feature/2017-total-solar-eclipse-above-madras-oregon

Page 102: Bailey's Beads
Credit: NASA/Carla Thomas
https://www.nasa.gov/centers/armstrong/multimedia/imagegallery/2017
_total_solar_eclipse/AFRC2017-0233-005.html

Page 105: Glittering Galaxies
Credit: NASA/MSFC/MEO/Aaron Kingery
https://www.nasa.gov/topics/solarsystem/features/watchthookies/galaxies1
.html

Page 106: Flaming Star Nebula
Credit: NASA/JPL-Caltech/UCLA
https://images.nasa.gov/details-PIA13447.html

Page 108: Sword of Orion
Credit: NASA/JPL-Caltech
https://images.nasa.gov/details-PIA14101.html

Page 109: Unicorn Rose
Credit: NASA/JPL-Caltech/UCLA
https://images.nasa.gov/details-PIA13126.html

Page 110: Canopus, or Alpha Carinae
Credit: NASA/JSC/ISS/Donald R. Pettit
https://images.nasa.gov/details-iss006e28068.html

Page 111: Helix Nebula
Credit: NASA/JPL-Caltech/ESA
https://images.nasa.gov/details-PIA03678.html

Page 113: A Diamond and Lizard in the Sky
Credit: NASA/GSFC
https://images.nasa.gov/details-GSFC_20171208_Archive_e000084.html

Page 114: Mystic Mountain
Credit: NASA/ESA/M. Livio and the Hubble 20th Anniversary Team
(STScI)
https://images.nasa.gov/details-GSFC_20171208_Archive_e002058.html

Page 115: Scorpion Claw
Credit: NASA/JPL-Caltech/UCLA
https://images.nasa.gov/details-PIA13128.html

Page 116: NGC 1333
Credit: NASA/CXC/JPL-Caltech/National Optical Astronomy
Observatory/Deep Space Station
https://images.nasa.gov/details PIA19347 html

Page 119: Crab Nebula
Credit: NASA/ESA/G. Dubner IAFE, CONICET-University of Buenos
Aires et al./A. Loll et al./T. Temim et al./F. Seward et al./VLA/NRAO/AUI/
NSF/Chandra/CXC/Spitzer/JPL-Caltech/XMM-Newton/ESA/Hubble/
STScl
https://images.nasa.gov/details-PIA21474.html

Page 120: GK Persei, aka Firework Nova
Credit: NASA/GSFC
https://www.flickr.com/photos/gsfc/19362366701/in/album
-72157655208938916/

**BILL NYE** (the Science Guy) is a science educator, actor, writer, and the host of the Netflix science show *Bill Nye Saves the World*. He serves as CEO of the Planetary Society, an organization founded by Carl Sagan. The Society engages citizens to advance space science, exploration, and effective space policy.

**NIRMALA NATARAJ** is a New York–based writer and editor with a background in science writing—particularly cosmology, ecology, and molecular biology—and a focus on the visual and performing arts. She is the author of *Earth + Space* and *The Planets*, also from Chronicle Books.

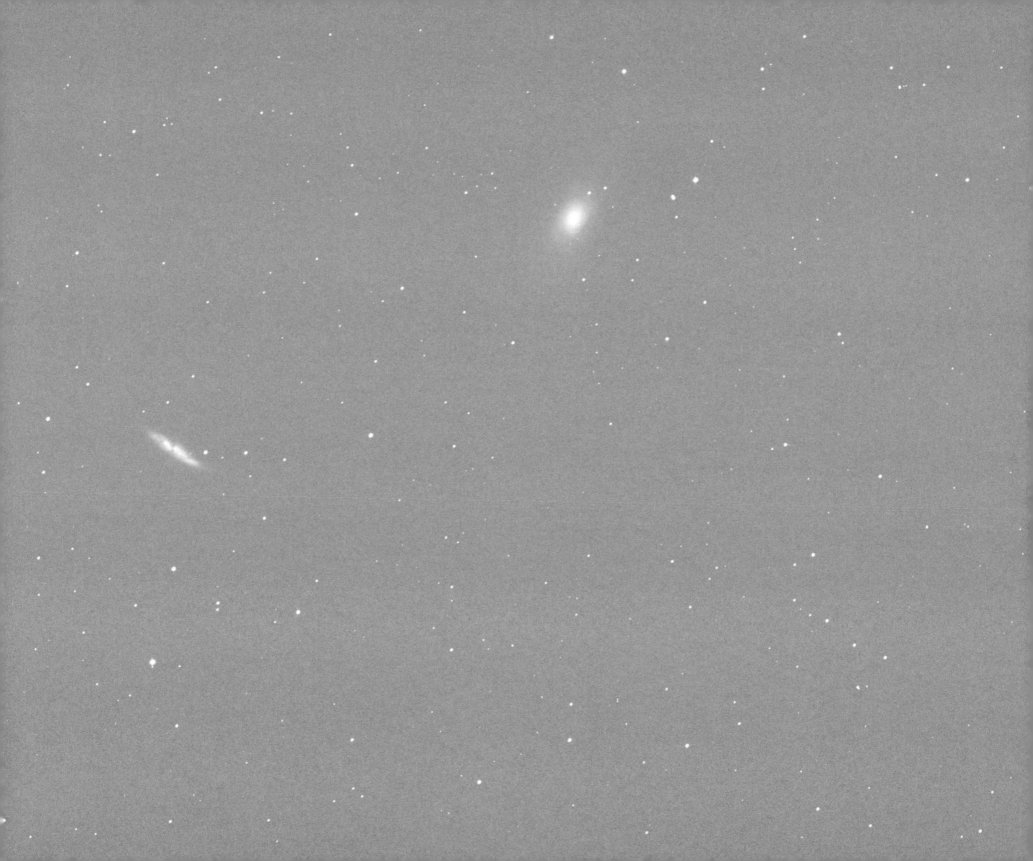

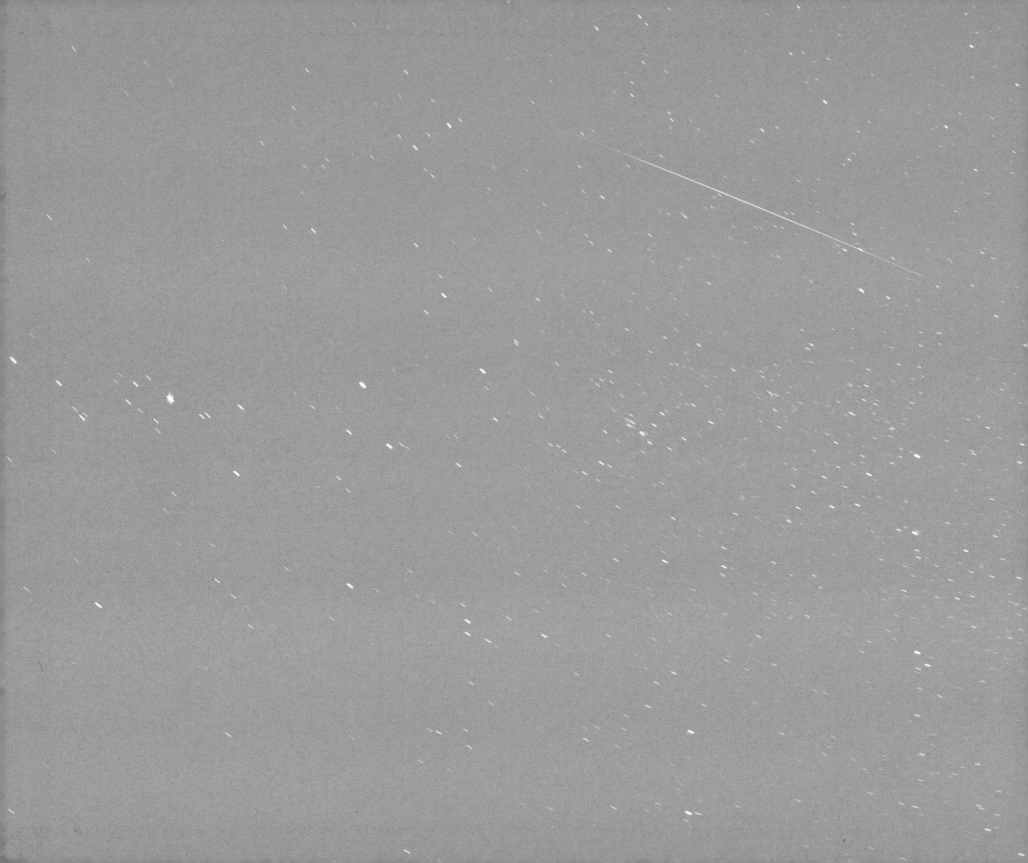